ABANDONED CHINATOWNS

NORTHERN CALIFORNIA

MARGARET LAPLANTE

AMERICA THROUGH TIME®

ADDING COLOR TO AMERICAN HISTORY

America Through Time is an imprint of Fonthill Media LLC
www.through-time.com
office@through-time.com

Published by Arcadia Publishing by arrangement with Fonthill Media LLC
For all general information, please contact Arcadia Publishing:
Telephone: 843-853-2070
Fax: 843-853-0044
E-mail: sales@arcadiapublishing.com
For customer service and orders:
Toll-Free 1-888-313-2665

www.arcadiapublishing.com

First published 2021

Copyright © Margaret LaPlante 2021

ISBN 978-1-63499-361-6

Typeset in Trade Gothic
Printed and bound in England

CONTENTS

ABOUT THE AUTHOR

MARGARET LAPLANTE is a historian living in southern Oregon. She has written many books, magazine articles, and short stories on the history of Oregon.

INTRODUCTION

News of the discovery of gold in California reached China by way of British and American trading vessels. Poor living conditions and civil strife engulfed China during this time. Floods wiped out the crops in 1847-1848. This was followed by the Taiping Rebellion that began in 1851 and ran until 1864. It was one of the deadliest civil wars in history and left many Chinese men looking for opportunities outside of China.

The opportunities that awaited the Chinese in America provided welcome relief from the strife at home. The long journey to a foreign land rife with uncertainties looked much more promising than the reality of staying put. As one Chinese farmer said:

> I work on four-mou land [less than one acre, a larger-than-average holding] year in and year out, from dawn to dusk, but after taxes and providing for your own needs, I make $20 a year. You make that much in one day. No matter how much it cost to get there, or how hard the work is, America is still better than this.

The Chinese who arrived on American soil did not intend to begin a new life here. They were here to earn enough money to provide for their families back home and to return to their homeland with financial security. The majority of the Chinese immigrants were young men who travelled alone, leaving their wives and children behind. For those who set out in the 1850s, they traveled by sailing ships that could take three months or more at sea. The 1860s saw the advent of the Trans-Pacific steamship which shortened the time to approximately forty-five days. The journey was excruciatingly difficult. The men were crammed into close quarters for the long and arduous journey. The fare to America was approximately fifty dollars. However,

that price could be doubled or tripled, and the interest rate could be unscrupulous. Those without the means to pay for their fare up front could enlist with one of the Six Associations based in China. The Six Associations would pay for their travel. Once they arrived on American soil, they were met by a China boss who worked for one of the Six Associations. The men had no option but to go to work for their new China boss in order to repay their debt. The men knew that their families back home could be in grave danger if they failed to repay their debt to the Six Associations.

The Chinese kept to themselves and honored the customs of their homeland. This created distrust amongst the non-Chinese. They ridiculed the Chinese for their manner of dress and their customs. The Chinese generally ignored the comments, but no town was immune from the fighting that broke out between the opposing parties. The feuds were usually about the Chinese being willing to work for lower wages. Moreover, the fact that they sent their wages back to China instead of supporting the local economy created resentment that frequently boiled over into large scale battles between the parties.

The fighting was not just between the Chinese and the pioneers. Different Chinese tongs were frequently in wars in Chinatowns throughout America. Some of the tensions carried over from their time in China; other disputes began anew while in the United States. The tongs were established to assist the Chinese navigate their time in America. Most of the tongs had the word benevolent in their title names. However, they soon became involved in illicit operations such as prostitution, opium dens, and gambling. Turf wars broke out amongst the tongs for their illegal operations in Chinatowns throughout the United States. The weapons of choice were hatchets and similar tools, and guns. The Six Associations attempted to stop the tongs with little success.

There was also the Wo Ping Wooey, a Chinese Peace Society that would attempt to arbitrate between the opposing tongs. However, the Chinese Peace Society had no control over the tongs. If the members of the opposing tongs had no desire for a resolution, then they did not meet with the Wo Ping Wooey.

During a tong war, a captain would be in charge. The soldiers beneath him would do the actual killing. Prices were set for the bounty, with the president of the opposing tong bringing in as much as $5,000. The soldiers worked in groups of at least three people. Once they killed the victim(s), they scattered in different directions, dropping their weapons at the scene of the crime. When reporting to a superior about the number of people killed, they would say that they had caught a particular number of fish that day. If a person was killed who was not a member of the opposing tong, just an innocent bystander, the tong would make restitution to the family. The tong wars diminished in the early 1900s.

It was the allure of gold that initially brought the Chinese to America. However, once they arrived in this new country, they found many obstacles blocking their dreams of striking it rich in the gold fields. For starters, the Chinese were not allowed to own mining claims. Once a pioneer abandoned the mining claim, a Chinese man could work it as his own. There were many instances where a pioneer had given up on the claim, only to learn later that a Chinese man had struck it rich. Most sought their own revenge; others sought the help of the court system. However, since the Chinese were not allowed to testify in court, the legal system served little purpose for them.

In 1897 one Chinese man summed up his feelings by writing:

I came to America to labor, to suffer, floating from one place to another, persecuted by the whites for more than twenty years. What is my goal for enduring this kind of pain and hardship? Nothing but trying to earn some money to relieve the poverty of my home. Do you know that both the old and young at my home are awaiting me to deliver them out of starvation and cold?

It did not take long for the resentments and tensions to turn into an Anti-Chinese movement. The slogan "the Chinese must go" was shouted throughout America. A Foreign Miners Tax was enacted in 1850 in California. The act required each foreign individual working in the gold mines pay $20 per month. Although the majority of the miners were from foreign countries, only the Chinese were taxed. The act was repealed the following year but was quickly replaced with the Foreign Miner's License Tax Act of 1852. This act charged each miner $3.00 per month, but was gradually increased over time. Again, only the Chinese miners were taxed.

The Chinese who worked in the fishing industry were not exempt from special taxes. The Chinese Fisherman's Tax was passed in 1860 which required each Chinese fisherman to pay $4.00 per month. The act also prohibited the use of Chinese fishing nets and the handmade boats used by the Chinese. The act was repealed in 1864. However, the Scott Act that became law in 1888 stated that if a Chinese individual left America, they could not re-enter for any reason. This meant that the Chinese could not fish more than three miles off the coast. This caused many of the Chinese to seek other work, because they could no longer make a living in the fishing industry.

Approximately fifty-eight Chinese men who lived on the East Coast fought in the Civil War. Some were for the North; others were for the South. During World War I, many of the Chinese living in the United States were drafted. Upon returning home from war, they expected to be granted citizenship. For some that was the case, but

many others were disappointed to learn that their application was denied. More than 12,000 Chinese men served the United States during World War II. Forty percent of those serving were not American citizens. In 1943, Chinese woman living in America were accepted into military service for the United States. The Chinese who served during World War II were granted American citizenship.

For some of the Chinese, their dreams of returning home wealthy were never realized. The men died here in America before they found their Gold Mountain. Due to the dangerous work they were engaged in, be it mining or blasting through mountains to build the railroads and tunnels, many were killed. Diseases and illness claimed the lives of others.

For those fortunate enough to bring their dream to fruition, they returned home to China bringing prosperity and thus honor to their family in a way they could not have achieved in their native land. Once back home, they held celebrations complete with firecrackers and huge feasts of food. Many of the returning Chinese invested in additional land for their families. Some built new homes and invested in business ventures. Not everyone who returned home was wealthy. Some never found their Gold Mountain but were nevertheless happy to return to their families. Others returned home only to find they had to turn their hard-earned money over to the Chinese government.

What no one could have foretold during the Anti-Chinese sentiment in the 1800s was that100 years later, archaeologists would do excavation of Chinatowns to learn more about what their life was like here in America. Throughout the country, but with an emphasis on the Pacific Northwest, archaeologists set out to discover all they could about the Chinese who were here during the nineteenth century. Due to the lack of garbage pickup, most refuse was simply buried in the ground during this time period. Common items found from these digs include pieces of pottery from bowls and other eating vessels, old bottles, animal bones (generally chicken and pig), Chinese gaming pieces such as fan-tan, ceramic and glass marbles, coins, pieces of opium pipes and tins, fragments of old cans, and pieces of jars. Much of the porcelain located was from a pattern known as "double luck" although some of the pottery was from the "four flowers" pattern. There were also fragments of eating utensils and cooking wares.

In the late 1980s an archaeological dig was conducted at a Chinese cord-cutting camp in the Tahoe National Forest. The Chinese were employed cutting wood for the railroad. The archeological dig revealed bones from pigs, cows, and fish. Evidence of opium and liquor was uncovered. Square oil cans and other tin cans had been flattened and cut and were used for shingles and siding. Holes had been punched in empty oil cans and used as sifters. A cooking stove had been fashioned out of

an old black powder can. There were remnants of tools such as axes, files, sledge hammers, and a froe. The archaeologists also uncovered food-storage vessels, porcelain tableware, and drinking vessels.

Occasionally human bones have been uncovered during archaeological digs. More times than not, the bones showed evidence of malnutrition. Some of the human bones had evidence of blunt force trauma.

The archaeologists performed studies on the soil at various Chinatowns. They frequently found evidence of rice, wheat, barley, and millet. There was also evidence of bitter melon, Chinese date, and agave. Additionally, Chinese medical remedies were frequently located in archaeological digs.

Archaeologists excavated an area at the Summit Pass where the Chinese worked building the Transcontinental Railroad. There they discovered the remains of a large roasting hearth possibly used to feed the many Chinese laborers. Most Chinese camps, whether they were in mines, in railroads or living in close quarters in Chinatowns, would have one or more cooks who would prepare the food.

In 1988, archaeologists discovered an almost intact store in San Francisco's Chinatown. They were tasked with doing an excavation of the site during a major construction job on the corner of Kearny and Sacramento Streets. Thousands of artifacts were unearthed including intact ceramic items, glazed clay decanters, medicine bottles, blue and white plates, rice jars, coins, tableware, and religious figurines.

1

SAN FRANCISCO'S CHINATOWN

Although San Francisco's Chinatown was never abandoned, today nothing remains of the original Chinatown.

The Chinese began arriving in San Francisco in the mid-1800s and quickly formed their own Chinatown. Some of the businesses were owned by the Associations; others were owned by individuals. As time went by and more of the Chinese paid off their debt to the Associations, they were able to own their own businesses

In 1883 the *Harrisburg Telegraph* newspaper described a trip to San Francisco's Chinatown:

Our first stop was at a grocery store. Here was everything in the line of eating. Whole pigs, roasted and hanging up, ready to be cut into very small pieces. Geese, cleaned, split and roasted and pressed as flat as a pancake, looking very much like a palm leaf fan. Sausages made of dog's meat, hanging in little bunches of half a dozen. A peculiar kind of cheese, made of goat's milk, in little squares, covered with a brilliant yellow paper wrapping. The fin of shark dried for soup, and a very small fish about an inch and a half long, used for soups, and esteemed a great delicacy. Vegetables of all kinds. Eggs brought from China. We were told that the eggs were two and three years old. They are preserved by being covered with some sort of gum and over that a substance looking very much like the mud on Third Street. We rubbed some of the mud off, broke the egg and found it fresh and good. There were many delicacies there. In fact, everything to tempt the appetite of a Chinese gourmand.

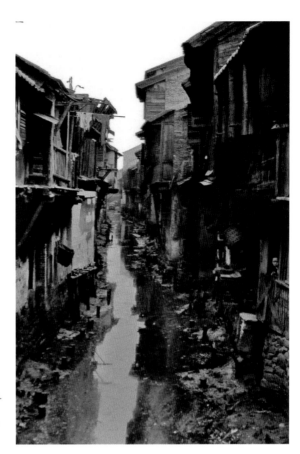

Left: Scenes from life in China in the 1800s.

Below: A glimpse of what life looked like for those living in China in the 1800s.

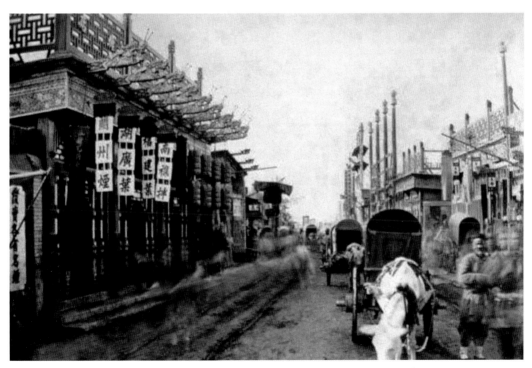

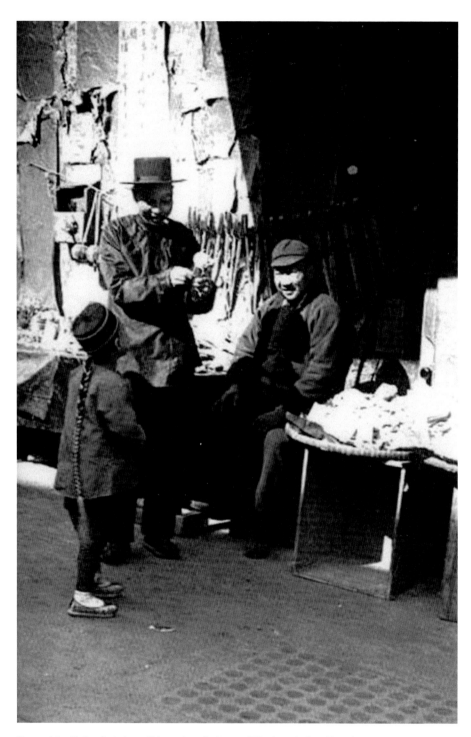

Some of the first arrivals from China set up their own Chinatown in San Francisco.

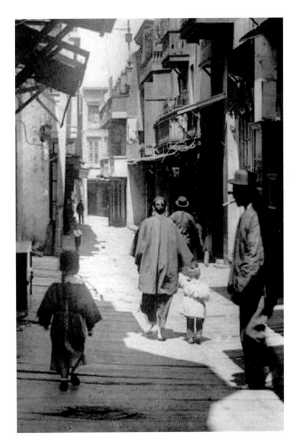

Right: These early photos of San Francisco's Chinatown show rudimentary wooden structures.

Below: As time went by, more permanent structures consisting of concrete, wood, and brick were constructed in San Francisco's Chinatown.

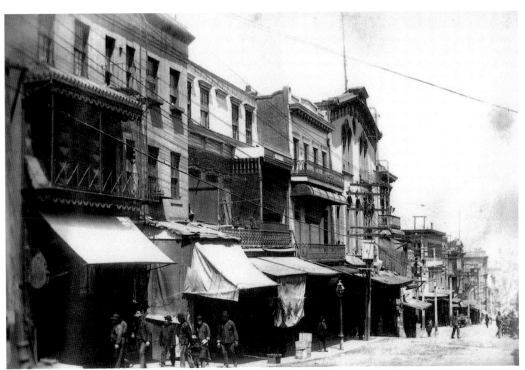

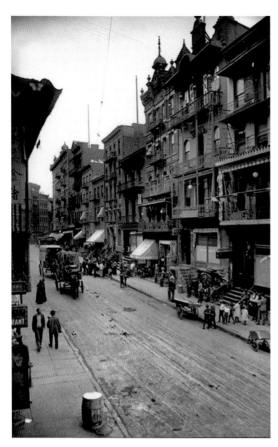

Left: Some of the buildings had ornate iron work on the upper levels.

Below: Ships arrived several times a year bringing supplies from China.

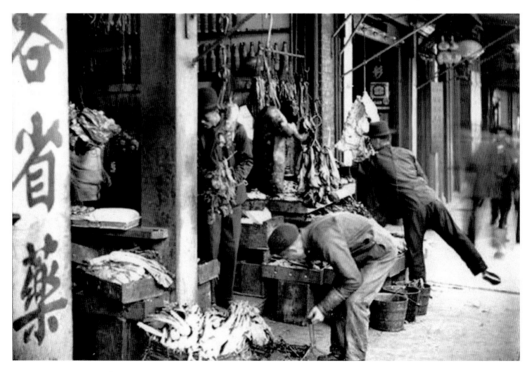

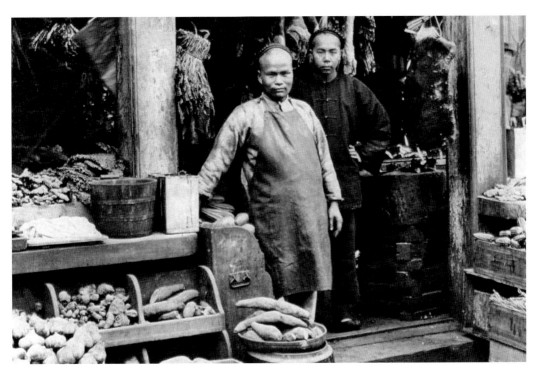

The markets in Chinatowns were not only a place to purchase items from their native land, but also a place to socialize.

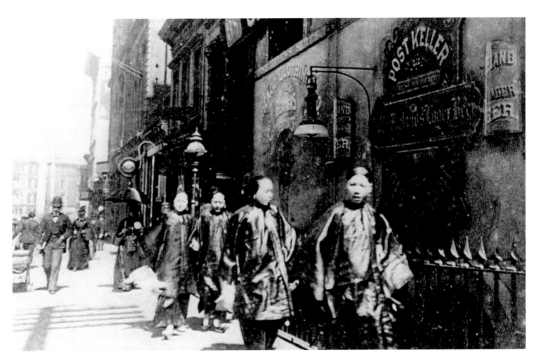

The women pictured are walking in San Francisco. For more than 1,000 years, young girls between the ages of three and eleven were expected to have their feet bound. Known as "lily feet," they were thought to be a symbol of gentility and high class. The actual practice of binding the foot consisted of pressing the toes under the foot. In 1911, the practice of binding a female's foot was outlawed when the Manchu Dynasty was toppled.

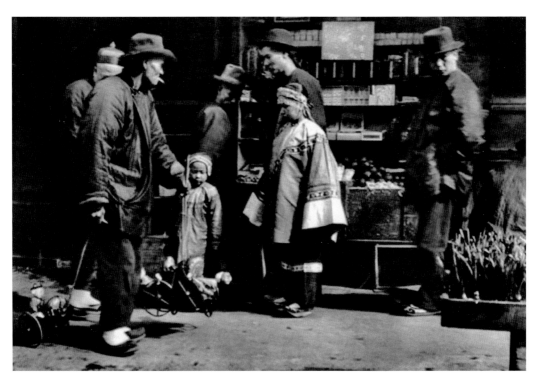

A Chinese vendor entertains a child.

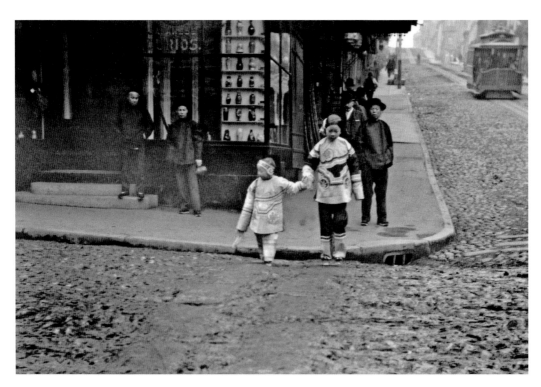

A cable car is making its way down a cobblestone street in San Francisco's Chinatown. San Francisco's cable cars made their debut in 1873. By 1890, there were twenty-three cable car lines running in San Francisco.

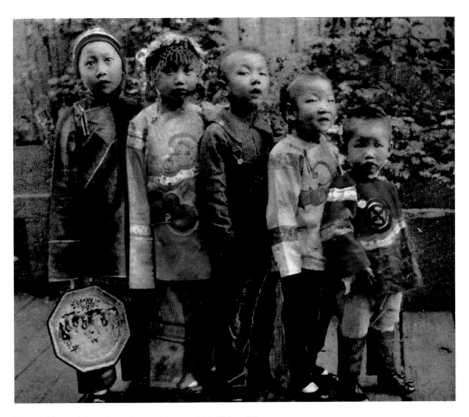

The children pictured are dressed in special holiday attire.

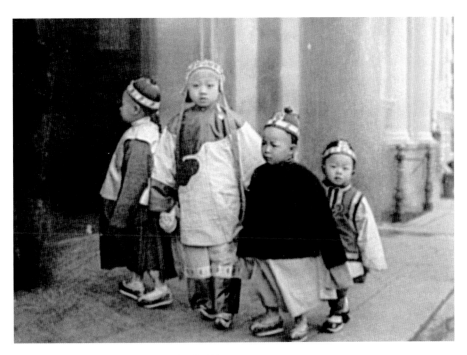

Young children are seen in San Francisco's Chinatown.

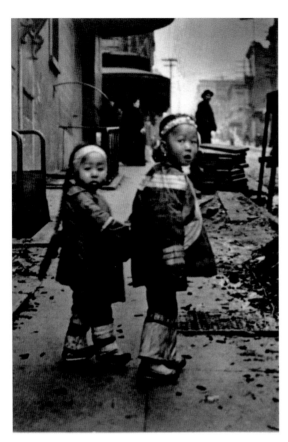

Left: In his column for the *Sioux City Journal*, "Driscoll On Tour," dated March 2, 1939, Charles Driscoll wrote: "The small children in San Francisco's Chinatown are among the most charming youngsters I've seen. They go about the streets, often two and two, holding hands for security, often carrying packages. The tiniest of them, appearing to be not more than 5, are unafraid of crowds and traffic. They are clean, neatly dressed, with chubby faces and wistful eyes."

Below: A young mother with her children walk by one of the many markets in Chinatown.

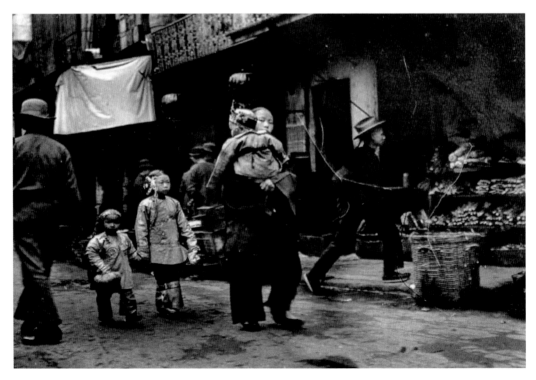

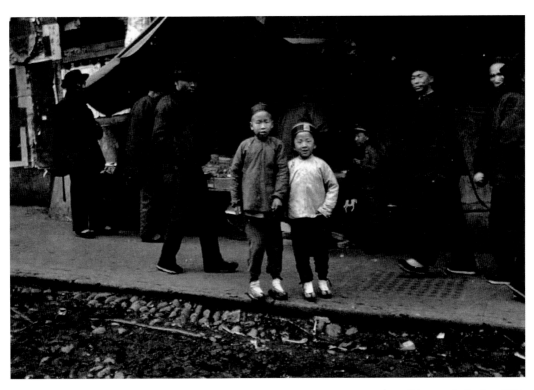

Children who attended schools in San Francisco's Chinatown studied both English and Chinese as far back as 1900.

It was common for the Chinese to carry their items in baskets draped over a pole.

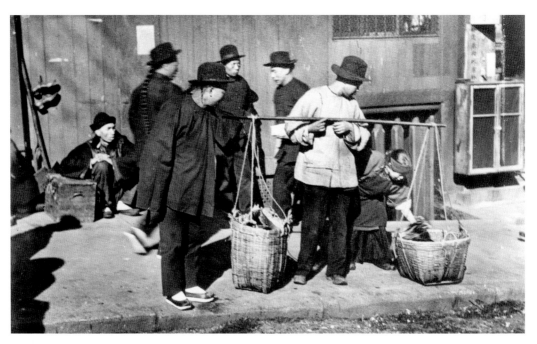

Some areas in America enacted the sidewalk law that prohibited baskets on poles, knowing that it would negatively impact the Chinese.

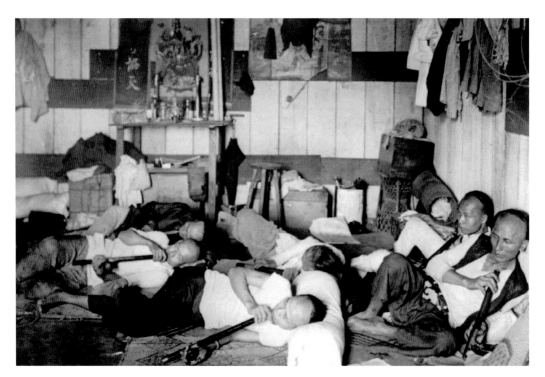

Chinese men are pictured in an opium den. Opium was brought from China on ships throughout the year. It was then transported to Chinatowns across the country. Police frequently arrested the Chinese for smoking opium. In the late 1800s, the U.S. government placed tariffs on opium being brought to America and they began a series of anti-opium laws.

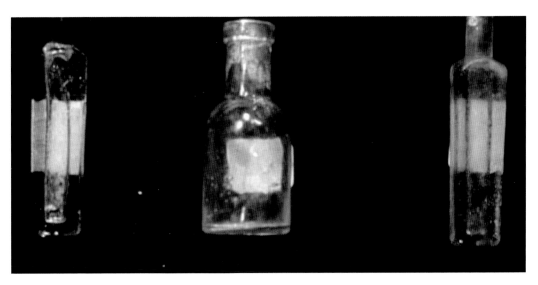

Pictured are bottles that once held opium. The bottles were uncovered in an archeological dig of a Chinatown.

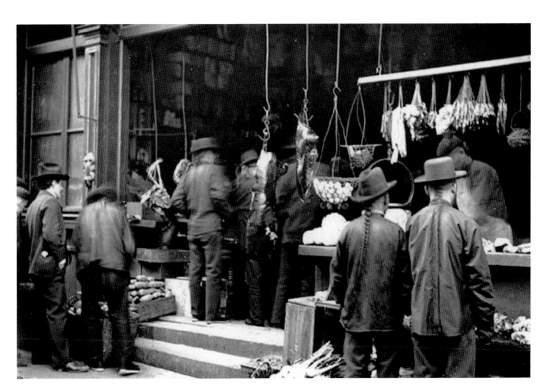

Under the Qing Dynasty, Chinese men were required to wear their hair in a queue. If a Chinese man returned to China without his hair in a queue, he risked being killed. After the fall of the Qing Dynasty men were no longer required to wear the hair in a queue.

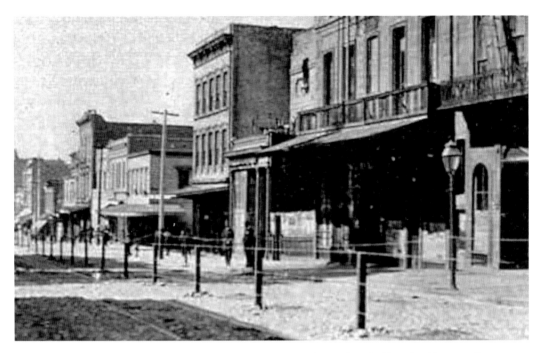

In 1900, the City of San Francisco ordered that barbed wire be placed around the buildings in Chinatown, thus placing the Chinese in quarantine. City officials believed that the bubonic plague was circulating throughout Chinatown after the death of a Chinese man. Police were stationed at every corner to prevent anyone from coming or going. An autopsy determined the man had died from complications from surgery, yet it was several months before the quarantine ended.

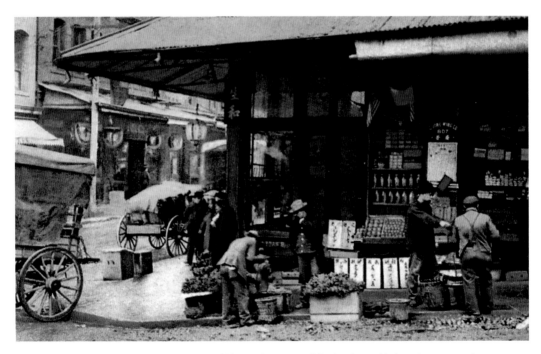

The markets in Chinatown served not only the Chinese, but some of the locals would shop there to purchase items that were not available anywhere else.

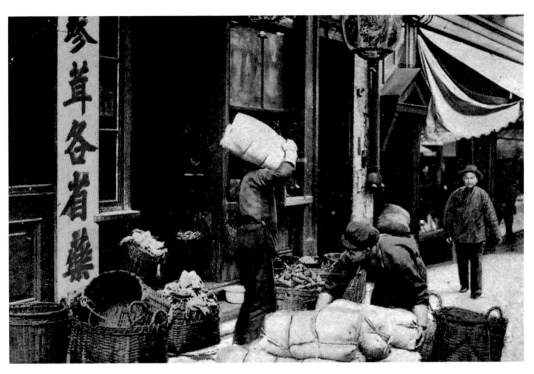

San Francisco's Chinatown became a tourist attraction as far back as the late 1800s. The tourists also shopped at the markets.

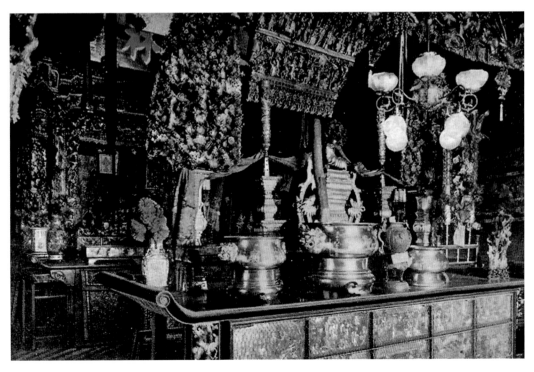

This postcard shows the interior of a Joss House in San Francisco's Chinatown. One of the first things the Chinese did upon arriving in any new area in America was to build a Joss House where they could worship.

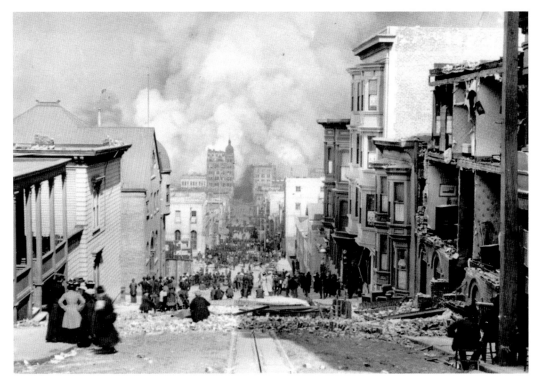

Early on the morning of April 18, 1906, life changed dramatically for those living in San Francisco.

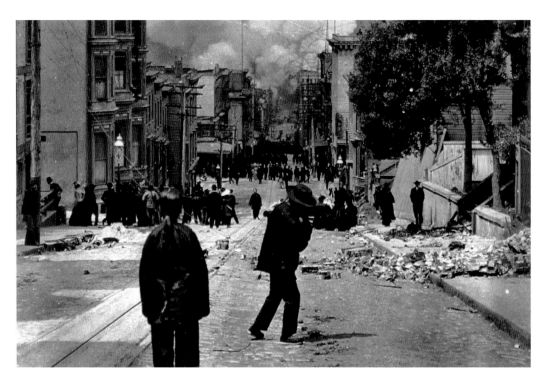

An earthquake measured at 7.9 on the Richter scale shook the Bay Area. People poured out of their homes and businesses and watched in disbelief. Those living within 300 miles in any direction felt the earthquake.

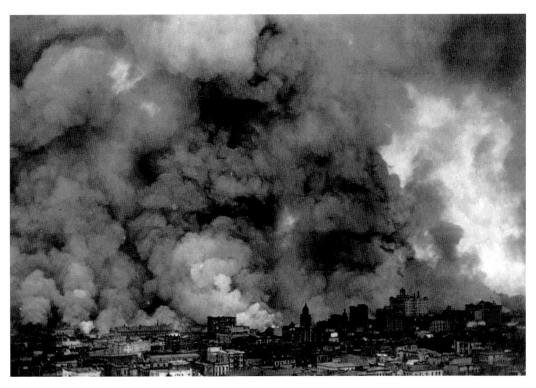

The earthquake ruptured gas mains throughout the city and within hours of the earthquake, fires broke out.

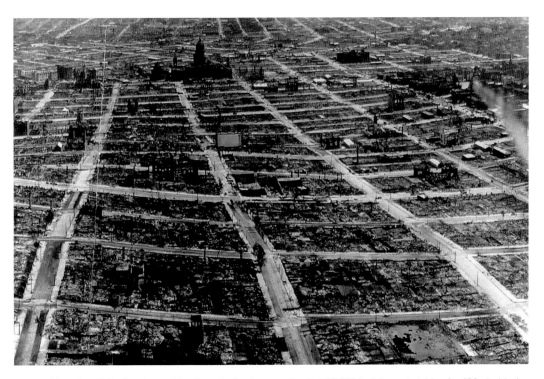

More than thirty fires burned for days, destroying an estimated 28,000 buildings stretching for 490 city blocks. An estimated 3,000 people died in the earthquake and fires.

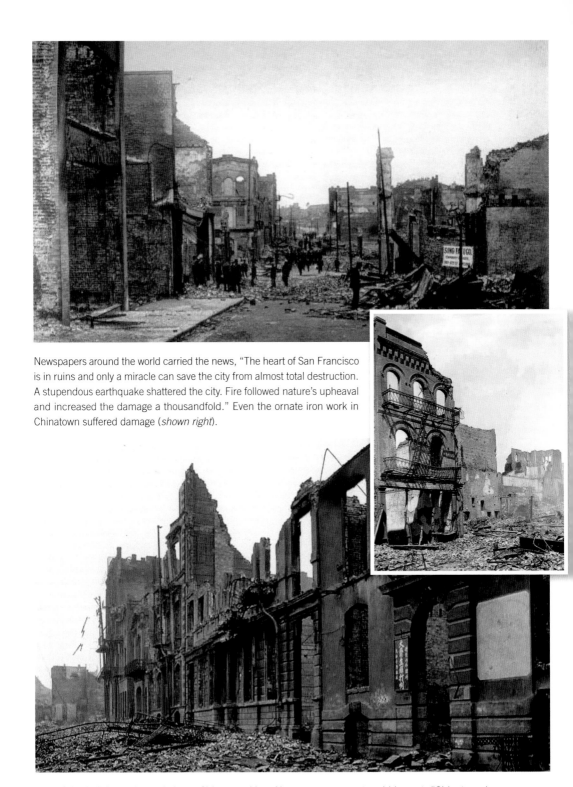

Newspapers around the world carried the news, "The heart of San Francisco is in ruins and only a miracle can save the city from almost total destruction. A stupendous earthquake shattered the city. Fire followed nature's upheaval and increased the damage a thousandfold." Even the ornate iron work in Chinatown suffered damage (*shown right*).

One of the buildings pictured shows Chinese writing. Newspaper accounts said in part, "Chinatown is now a reminiscence. Panic reigns among the countless thousands of Chinese, and they fill the streets, dragging whatever they could save from the wrecks."

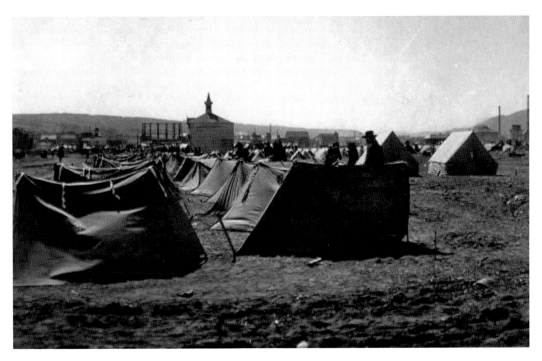

After the earthquake and fires, many of the Chinese moved away and were able to find work in other parts of the country. Others remained in San Francisco and lived in the tents pictured.

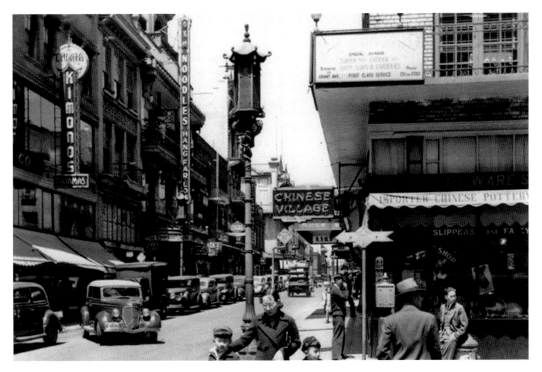

When plans got underway for San Francisco to rebuild, many officials fought to remove all traces of Chinatown. They wanted to push the Chinese out to the city limits. They believed the real estate was too valuable to be "wasted" on a Chinatown.

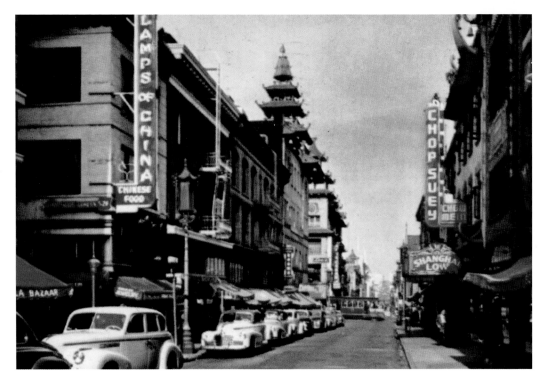

The city officials reasoned that if the city moved the Chinese to the outskirts of town, they would still reap the benefits of the cheap labor the Chinese provided. The Chinese prevailed and Chinatown was rebuilt in the original area.

This vintage postcard shows California Street.

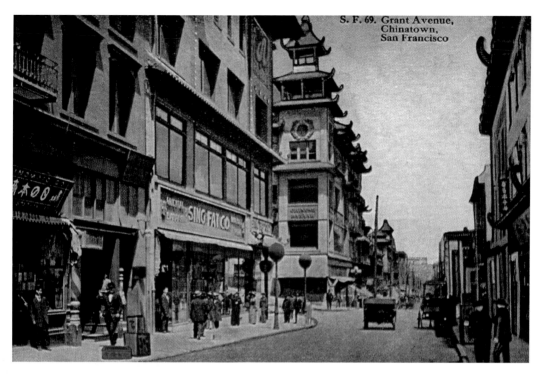

This postcard depicts Grant Avenue in San Francisco's Chinatown. Grant Avenue is one of the oldest streets in San Francisco's Chinatown. The original name of the street was Dupont. When the street was rebuilt after the earthquake and fire, it was named Grant Street in honor of past President Ulysses Grant.

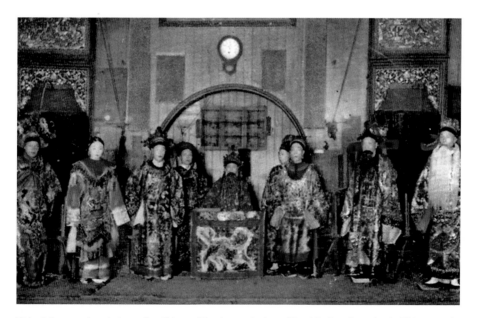

This vintage postcard shows the Chinese Theater on Jackson Street in San Francisco's Chinatown. In 1869, the *San Francisco Call* reported: "A few weeks ago, the proprietor of the Chinese Theater on Jackson Street returned from China, bringing with him a company of ninety performers, that had been performing for many years at Canton, and who had a wide reputation for talent as acrobats, vaulters, vocalists and general performers."

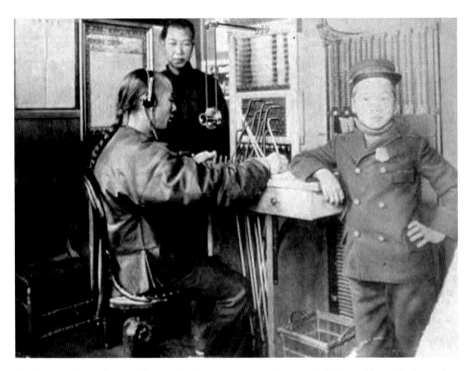

The Chinese pictured are working as telephone operators using an early PBX machine. [*Photo courtesy of Placer County Museums*]

When a telephone call came in over the PBX machine, a "runner" would run outside and try to locate the person and relay the message.

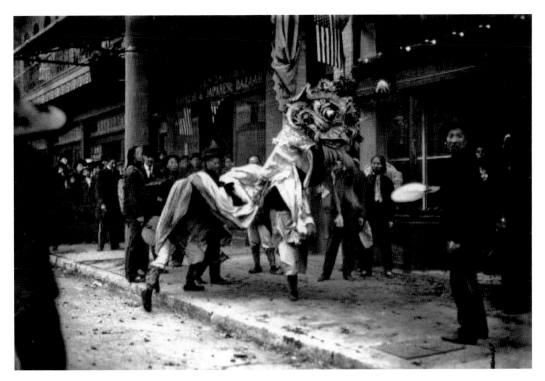

It was very important to the Chinese to maintain their native traditions such as Chinese New Year's in their adopted country.

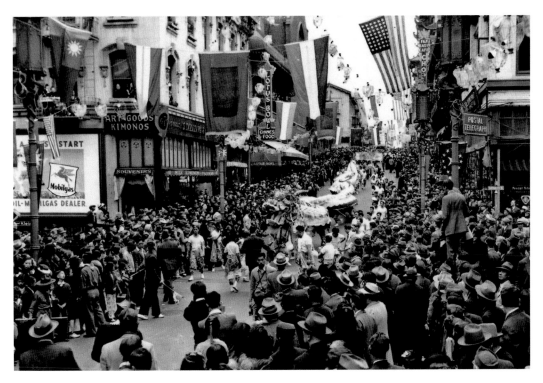

Pictured is a Chinese New Year's celebration in San Francisco's Chinatown.

The Chinatown in San Francisco is the oldest Chinatown in America.

Today San Francisco's Chinatown remains a vibrant part of the Bay Area. Tourists come from around the globe to visit.

2

CHINATOWNS THROUGHOUT NORTHERN CALIFORNIA

The Six Associations delivered the new arrivals to gold fields throughout California and the western states. They moved frequently from one gold strike to another. They slept in rudimentary wooden structures and lean-tos. If they stayed in one area for a period of time, Chinatowns began to emerge. A Joss House was built, stores opened, and more housing was built. The housing was still very basic—there were no foundations, and the houses were built in long rows, all connected to one another. Fires swept through Chinatowns continually, but the Chinese showed their resiliency by rebuilding time and time again.

In addition to mining, the Chinese built railroads; they worked in agriculture, logging and factories; they planted vineyards in the wine country; they cleared the delta, diverting water so that crops could grow on land where only water had been; they built underground tunnels; they dug canals so water could be diverted for agriculture; they installed irrigation for orchards; and they worked in the fishing industry and in canneries. They worked as servants in private homes, and they worked in hotels and restaurants. They operated laundries, restaurants, markets, and other stores. They also ran brothels, opera houses, gambling houses, Chinese theaters, and opium dens.

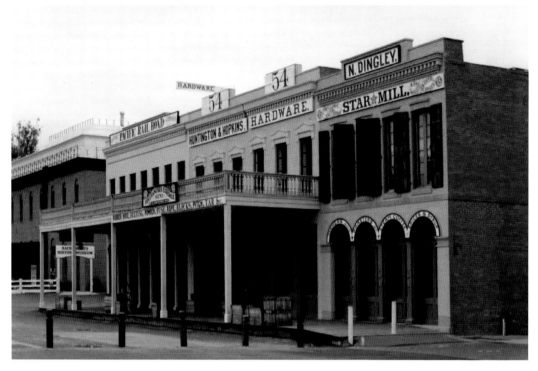

The first Chinese settlers in Sacramento lived on what is now known as I Street.

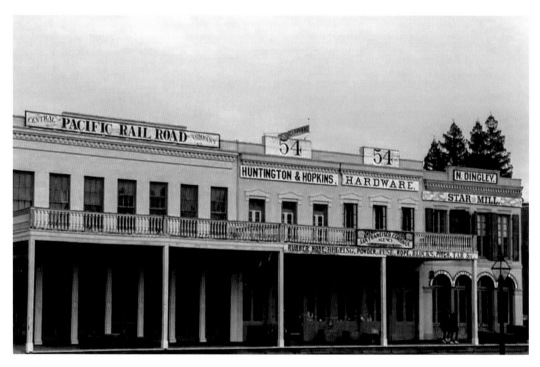

The Chinese referred to Sacramento as "Yeefow," meaning second city after San Francisco. Many of the Chinese worked on the docks of the Sacramento River. The Sacramento River played an important role in delivering supplies that were distributed throughout Northern California.

Pictured is the Howard and Mabel Chan House on Sutter Street in Folsom. Howard's father, Chin Oak, arrived in Folsom in 1852. He became the mayor of Folsom's Chinatown, a title that Howard later held. Howard was a part owner of Chan's Market. Folsom was home to more than 2,500 Chinese at the height of the Gold Rush.

Thousands of Chinese worked in the Sacramento-San Joaquin River Delta. They constructed earthen levees, turning 500,000 acres of swamp land into prime agriculture land. Many of the Chinese lived in Isleton during the project.

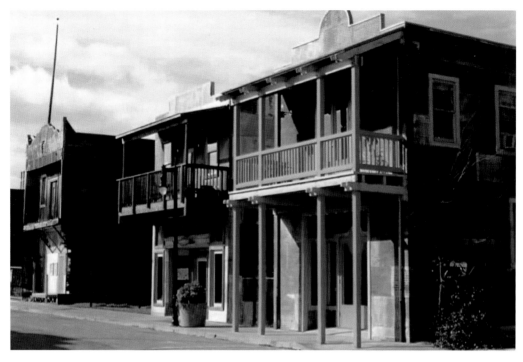

After the levee project was finished, many stayed in Isleton working in the agriculture and canning industries.

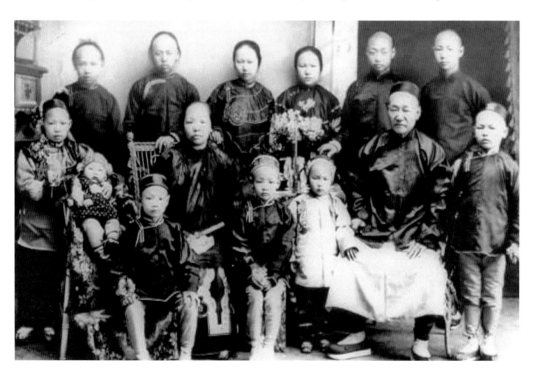

The Napa Valley was home to three Chinatowns. There were Chinatowns in Napa, Calistoga, and St. Helens. Pictured is the Chan Wah Jack family. Mr. Jack operated the Lai Hing Company, an herb and general merchandise store. A devastating fire in Napa in 1902 destroyed most of Napa's Chinatown. Those that remained after the fire were removed in 1939 to make room for a yacht harbor that never materialized.

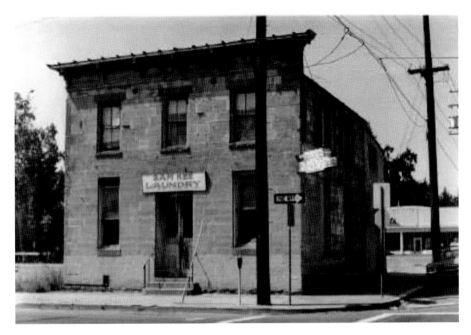

This building was built by Bavarian immigrant Phillip Pfeiffer in 1875. It served as a brewery and a saloon and brothel, prior to Sam Kee operating a laundry business. City officials tried to force him out in the 1940s by declaring that no laundries could operate in the area where his business was located. He took his case to the Supreme Court and won.

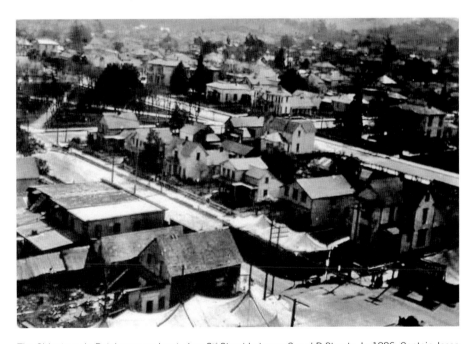

The Chinatown in Petaluma was located on 3rd Street between C and D Streets. In 1886, Captain Jesse Wickersham and his wife, Sarah, were found murdered. The investigators believed that Ah Tai Duck, their Chinese cook, was responsible. He was located on a ship to China and confessed. Detectives from Sonoma County travelled to Hong Kong to bring him back to stand trial. When they reached Hong Kong, they learned Ah had committed suicide.

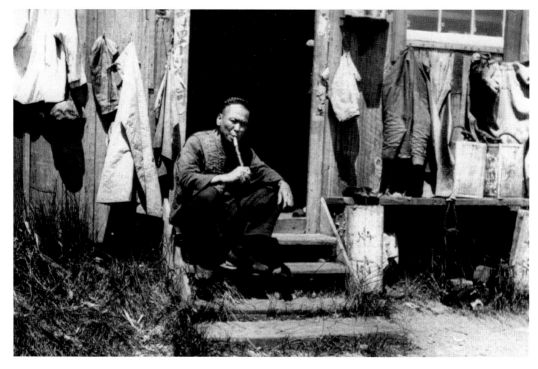

A Chinese man in Sebastopol is pictured. There was a time in the late 1800s that Sebastopol had two separate Chinatowns. The last of the buildings were razed in 1945.

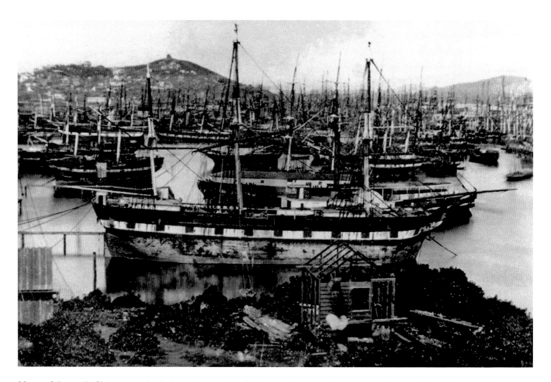

Many of the early Chinese worked along the coast in fishing and cannery businesses. Some of the Chinese had honed their skills working in the fishing industry in China and brought those skills to America.

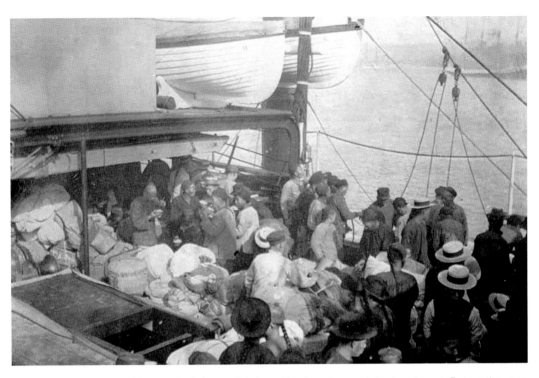

The Chinese were able to catch abalone and shrimp without needing specialized equipment. Early on there was not much demand for shrimp in California so the shrimp was dried and sent to China.

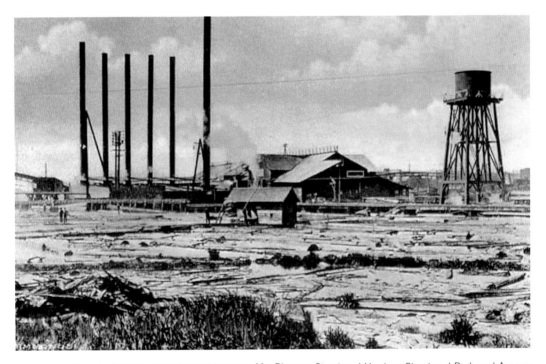

Fort Bragg's Chinatown was located between MacPherson Street and Harrison Street and Redwood Avenue and Laurel Avenue. Many of the Chinese living in Fort Bragg worked at the lumber mills, including the Union Lumber Company Mill pictured.

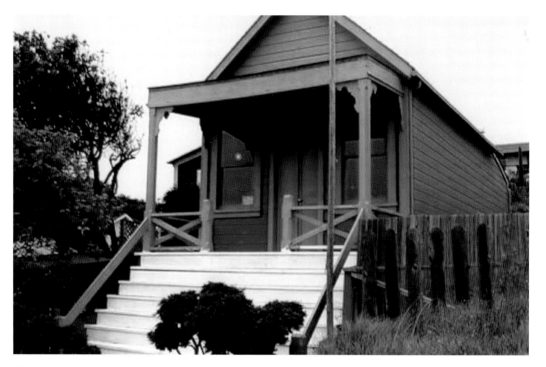

Pictured is the Joss House in Mendocino. The Joss House was constructed of redwood from the nearby redwood trees. It is the only surviving Joss House along the Northern California coast and the only surviving building from Mendocino's Chinatown.

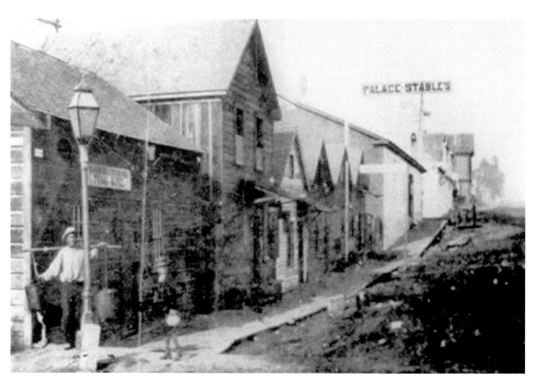

Approximately 200 Chinese made their home in Eureka's Chinatown.

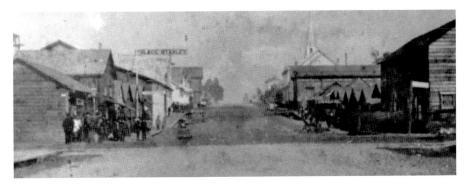

On February 7, 1885, the City Marshall, David Kendall, was struck by a stray bullet while walking to his office while a tong war was taking place. The townsfolk held a meeting the next morning and decided to expel all the Chinese.

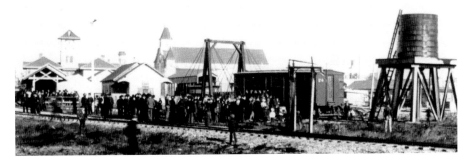

A committee was appointed, and they went door to door in Chinatown ordering that everyone leave Eureka within twenty-four hours.

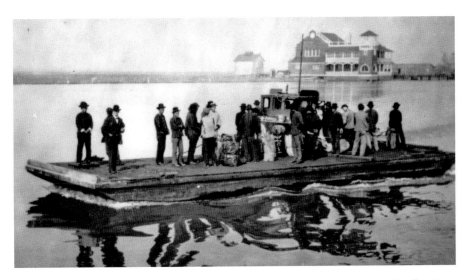

The Chinese were held in a warehouse until the next steamer arrived to transport them to San Francisco. Another committee was appointed to prevent any Chinese from settling in Eureka in the future. The news of what happened in Eureka was carried in newspapers across the country and helped to propel the anti-Chinese sentiment.

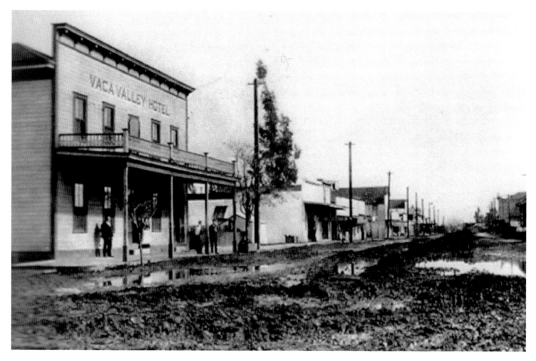

Many of the Chinese who lived in Vacaville worked in the fruit industry. Frank Buck owned 12,000 acres of fruits and vineyards in Vacaville. He paid his Chinese workers $1 per day, the same wage that he paid the non-Chinese.

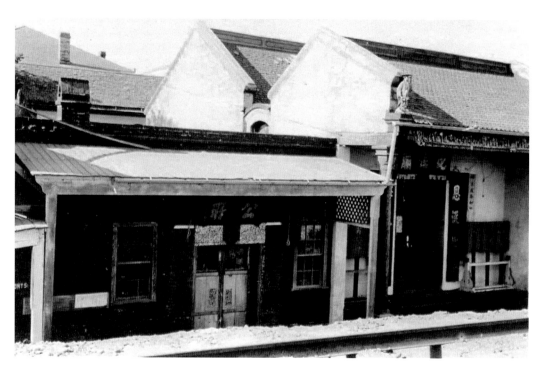

Marysville had a large Chinese population.

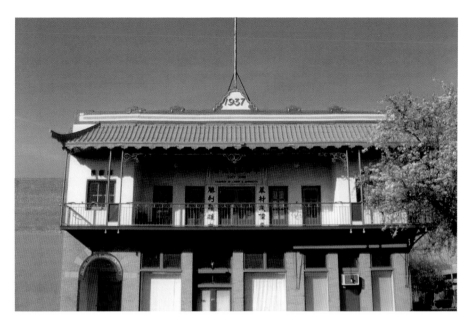

Pictured is the Suey Sing Tong building on C Street. The Suey Sing Tong was established in America in 1867. They protected their members from other tongs. On February 13, 1917, Sheriff McCoy received word that members of the Bing Kong Tong were on their way to Marysville to even a score. The sheriff was unable to locate the members, but he warned the Suey Sing Tong to be "on their guard."

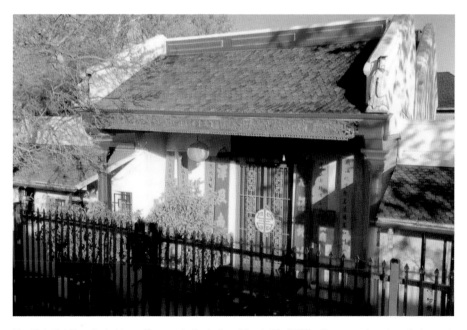

The Bok Kai Temple in Maysville was dedicated on March 21, 1880, after a previous temple burned. Bok Kai is the Water God. The Bomb Day Festival is still held every year in Marysville to honor the Water God. Bombs are set off in a controlled area. Those who locate the good fortune ring inside are thought to have good fortune all year long.

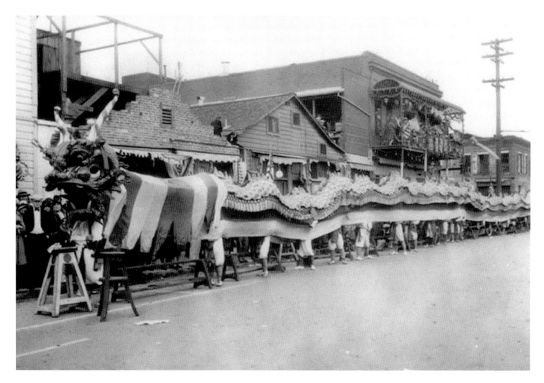

Pictured is a Chinese New Year's celebration in Marysville. The dragon was brought from China and was one of the largest dragons in California. It took forty people to keep it upright. The head and the tail were so heavy that the people operating them had to switch out with other people every block.

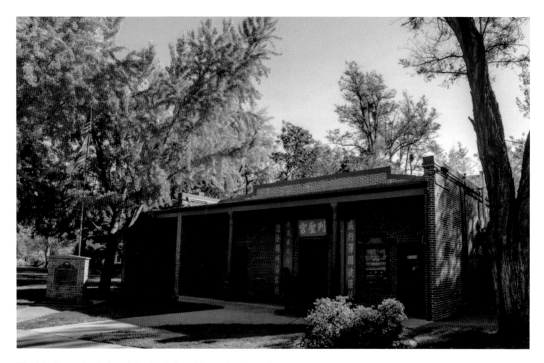

The interior and exterior of Oroville's Joss House is pictured.

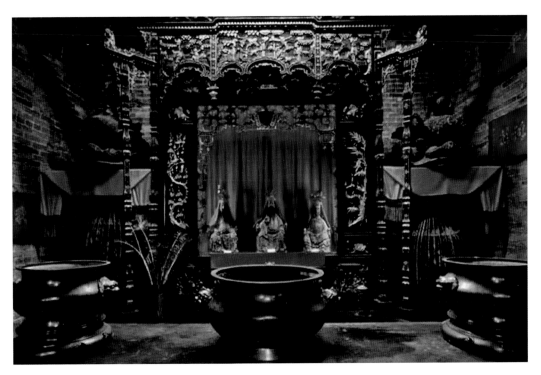

This was the third Joss House in Oroville's Chinatown; the first two burned. This Joss House was built in 1863 using bricks manufactured in nearby Palermo. In 1937, after a series of vandalism and thefts, the town decided to turn the Joss House into a museum. The Chinese who were living in Oroville at the time agreed to this with the stipulation that the Joss House also be available for worship.

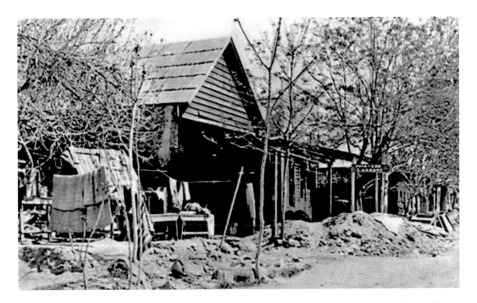

Pictured is one of three Chinatowns that were located in Chico. The first Chinatown was on Flume Street, which was referred to as Old Chinatown. New Chinatown was on Cherry Street. There was yet another Chinatown on Humboldt Ave. All three fell victim to fires and one was badly damaged in a flood. Each time a fire destroyed one of Chico's Chinatowns, city officials tried to prevent them from rebuilding. The Chinese prevailed and rebuilt each time, but in 1938 the last of the Chinese left the area.

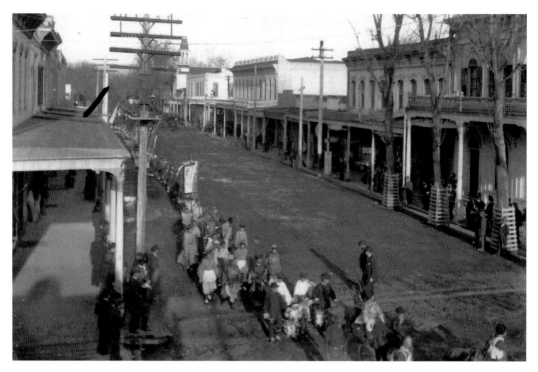

The Chinese New Year's celebration began with firecrackers set off at Sam Sing's Laundry on Main Street in Chico followed by a parade through downtown.

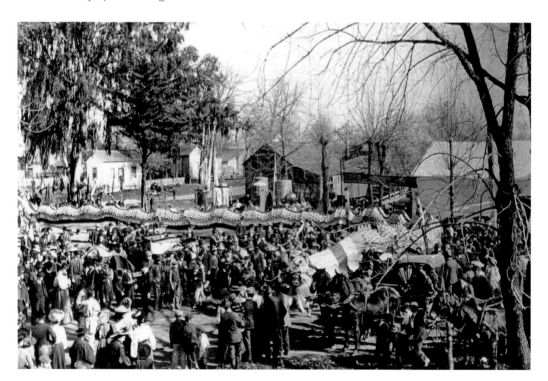

In later years the Chinese used a dragon that belched live steam as it made its way through the crowds in Chico.

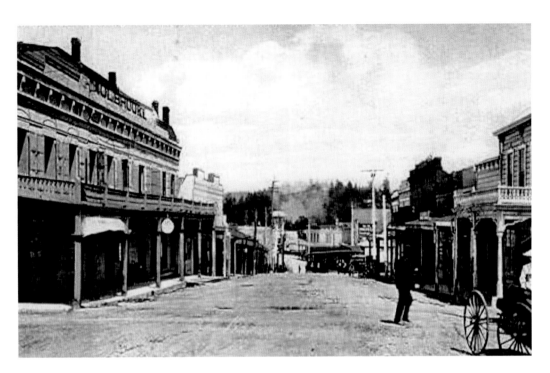

Above: Grass Valley was home to many early Chinese settlers. In 1904, the *Morning Union* described the election of the Joss Keeper. "The usual method of firing bombs into the air was resorted to and several were exploded before the lucky one was found. There was a great scramble for the coveted place, but the active Yee Lee outwitted his fellow countrymen and captured the ring which entitles him to the honor and salary, which is about $100 a year."

Right: Pictured is a man who was known as "Duck Egg" in Grass Valley. In 1921, a "conscience fund" was created asking that anyone who had ever "made sport" of him, threw rocks at him, or otherwise wreaked havoc on him contribute 50-cent pieces to help him financially.

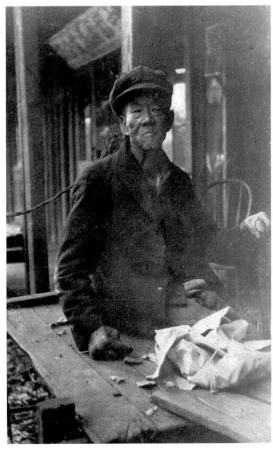

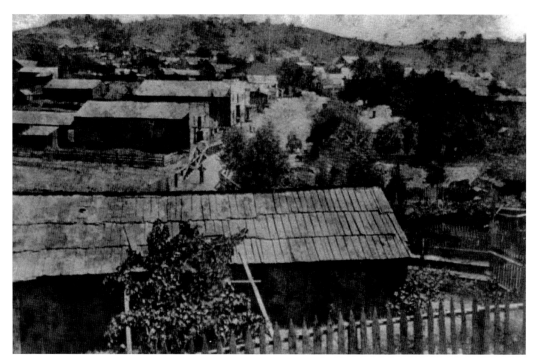

Drytown in Amador County was once home to many Chinese who worked in the gold mines. On May 23, 1922, the *Sacramento Bee* reported, "In Drytown the precious metal was found near the surface, and $100 to the pan was not an occasional occurrence. Along the ravines and gulches gold was in evidence and even the roots of the grass contained the metal much sought after."

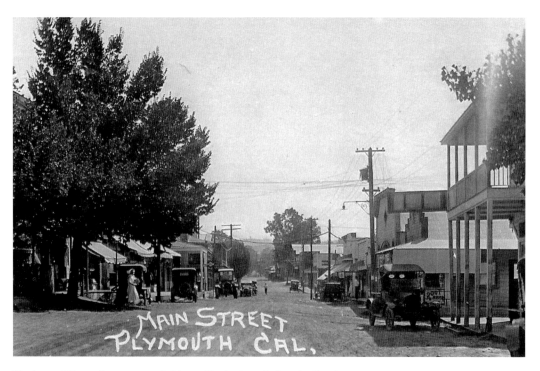

The town of Plymouth was once a thriving gold mine town in Amador County.

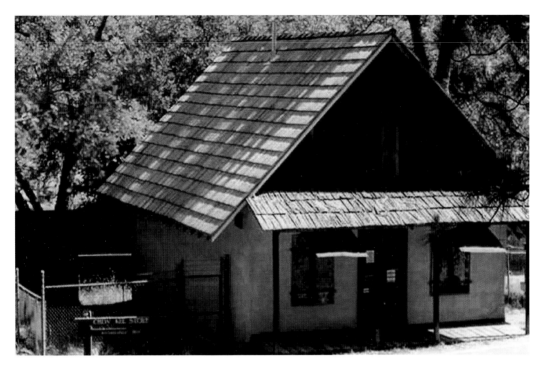

Also in Amador County is Fiddletown. For a time, it was renamed Oleta, but in 1932 the residents wanted to return to the original name. The Chinese began arriving in Fiddletown in 1852 and set up their own Chinatown. They were pressured to leave the area and in 1884 their Chinatown became a victim of arson. The gambling hall, a general store (pictured), and the Chew Kee Store survived. Today Fiddletown is a National Historic Landmark.

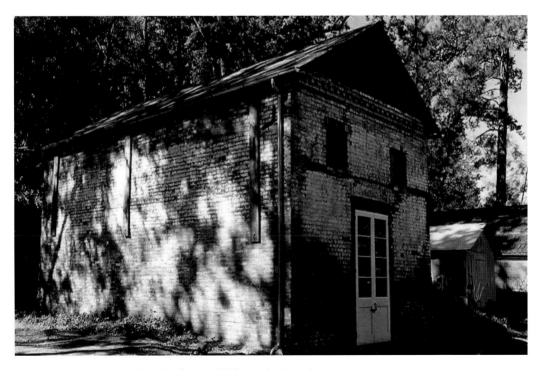

The exterior of the Chew Kee Store in Fiddletown is pictured.

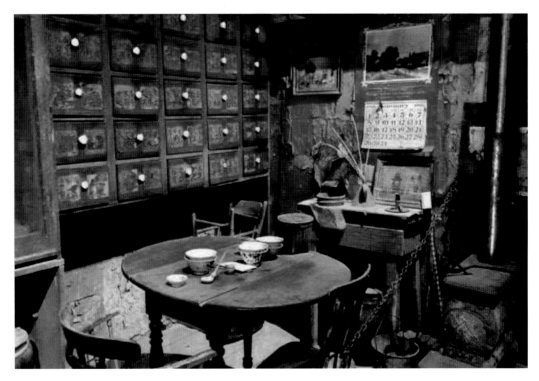

Shown is the interior of the Chew Kee Store in Fiddletown.

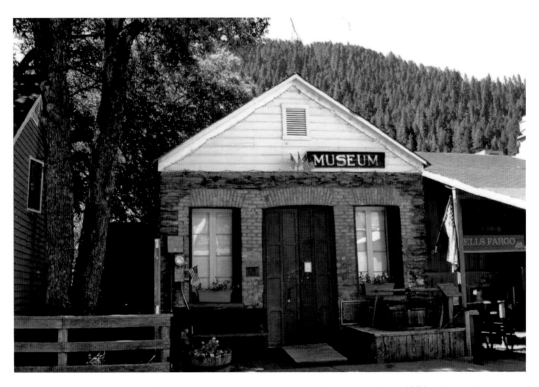

Downieville's Chinatown was on Main Street. This stone building was built in Downieville in 1852 and served as a Chinese store. The building has been a museum since 1932.

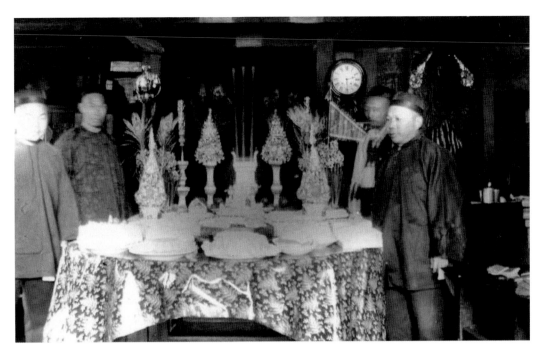

These men are celebrating Chinese New Year's inside the Joss House in Auburn in the late 1890s. The town of Auburn was part of the 49ers Mother Lode. Gold was discovered in Auburn in 1848 by Claude Chana. Associations brought thousands of Chinese to work the mines in Auburn.

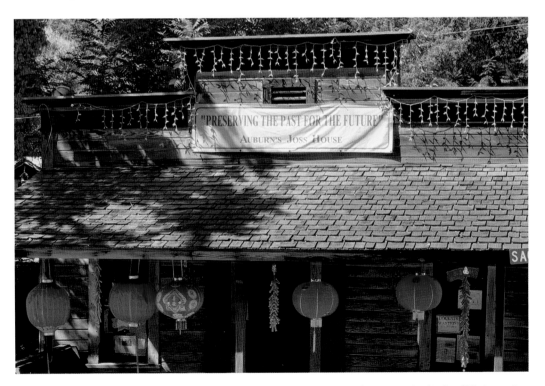

This Joss House in Auburn was built in 1920 to replace a previous one that succumbed to fire. [*Photo courtesy of Auburn Joss House*]

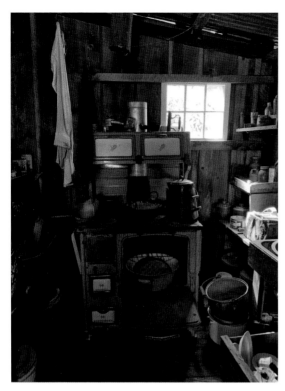

Left: The kitchen pictured is inside the Joss House in Auburn. The kitchen was used for social gatherings as well as by newcomers that stayed at the Joss House until they found suitable housing. [*Photo courtesy of Auburn Joss House*]

Below: Pictured in the classroom inside the Joss House in Auburn. Chinese children living in Auburn attended a full day of English-speaking school. When they finished that, they would attend school in the Joss House to further their Chinese studies. The Auburn Joss House is now used as a museum. [*Photo courtesy of Auburn Joss House*]

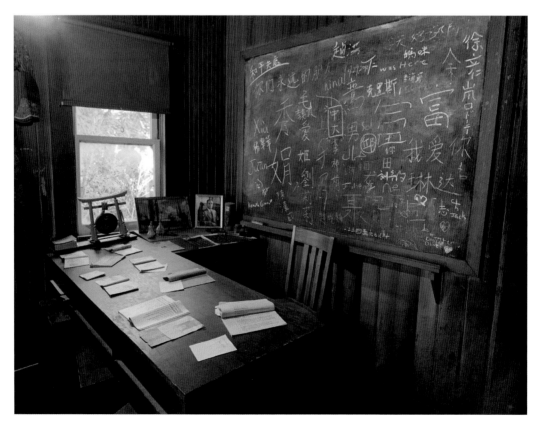

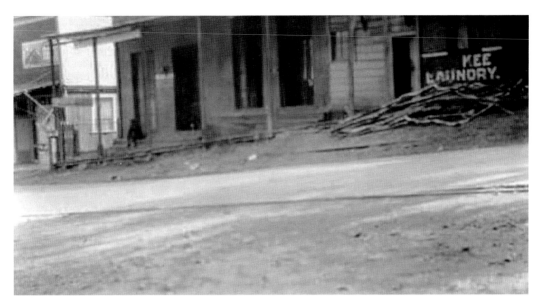

The Chinatown in Auburn is pictured. [*Photo courtesy of Placer County Museums*]

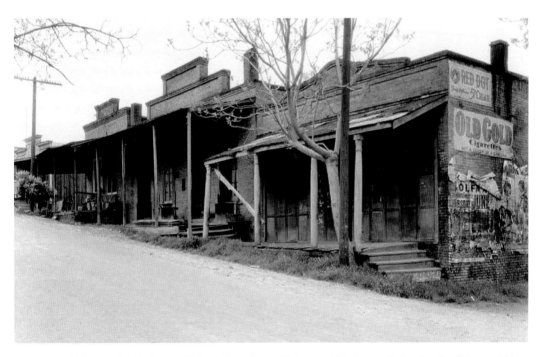

In 1964, Madeline Rexinger told the *Auburn Journal* that as a child she recalled seeing the Chinese children playing on the wooden sidewalks in front of the stores lining Chinatown. She said that the Chinese families lived behind or above the stores. She recalled how the Chinese men would walk single file into town to the post office, the oldest man in front with the youngest man in the rear.

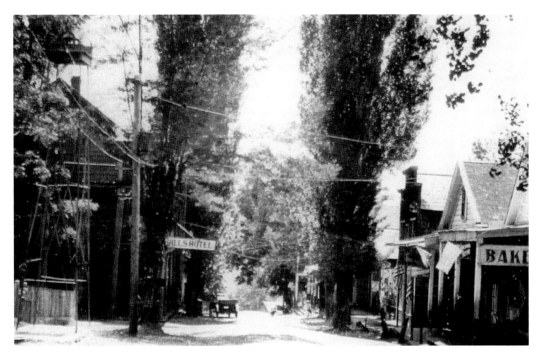

The town of Dutch Flat is pictured. The Chinese who made their home in Dutch Flat's Chinatown worked in the mines, in the railroad and logging industries, and they operated businesses. Some of the Chinese were even employed as soaproot gatherers collecting material used by the Eureka Hair Company for mattress fillings.

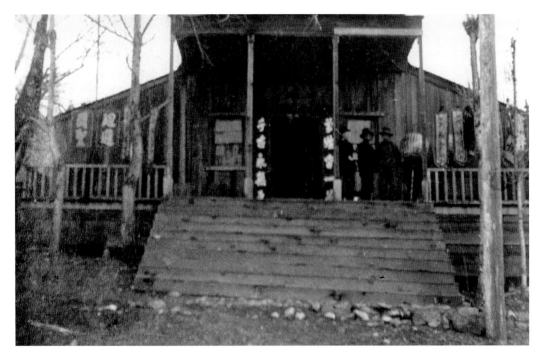

A man and a child are in front of the Joss House in Dutch Flat's Chinatown. The Chinese characters above the door read "New Chinatown Dutch Flat." A fire destroyed the earliest Chinatown in 1877. In 1881, a fire destroyed all sixty of the buildings in Chinatown. Undeterred, they rebuilt each time. [*Photo courtesy of Placer County Museums*]

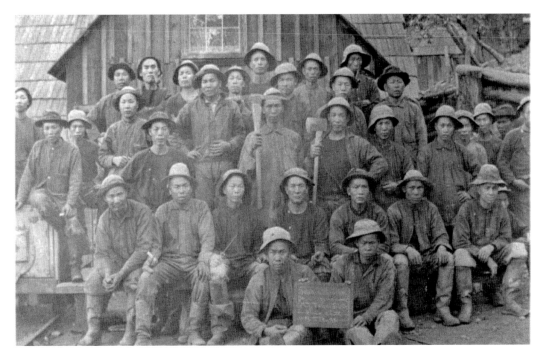

The Chinese played an important role in the history of Placer County. As part of the Mother Lode country, Placer County was home to thousands of Chinese who worked in the gold mines. The Chinese are pictured in front of the Hidden Treasure Mine on May 10, 1853. [*Photo courtesy of Placer County Museums*]

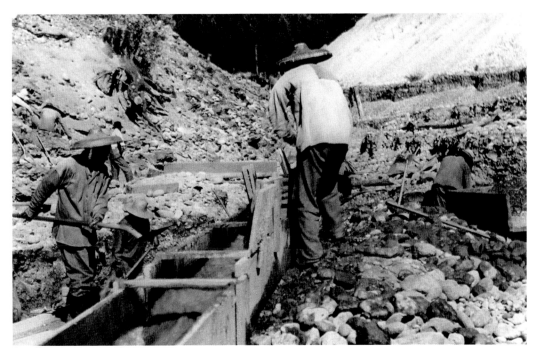

Early on the miners were able to mine for gold using rudimentary tools and equipment. But once the easy gold had been claimed, it was necessary to bring in heavier equipment. [*Photo courtesy of Placer County Museums*]

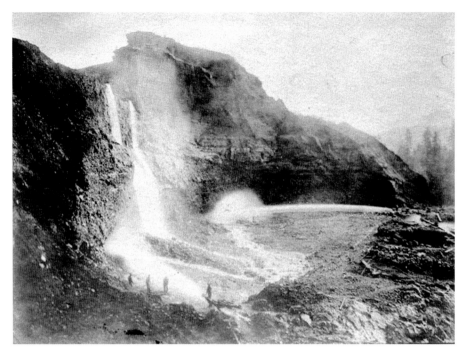

Hydraulic mining consisted of huge water pipes called "giants" that forcefully sprayed the area with a tremendous blast of water.

Pictured is the Shanghai Restaurant in Auburn. When Charlie Yue operated the Shanghai Restaurant, he used to check the inside of the ducks he prepared to see if there were any gold pieces due to the fact that the ducks frequented a pond nearby that had gold in it. [*Photo courtesy of Placer County Museums*]

Charlie Yue also purchased gold from the miners as seen in this photograph. Mr. Yue is talking with M. W. Buck and Ed Brown. [*Photo courtesy of Placer County Museums*]

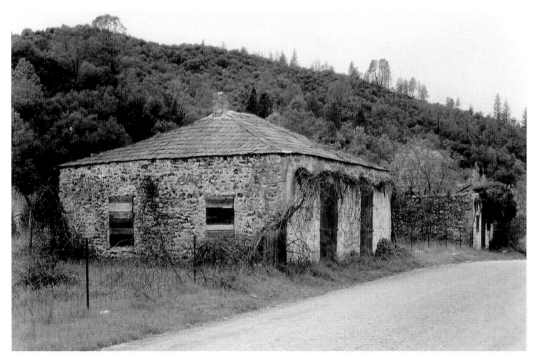

The remains of a Chinese store near the town of Coloma is pictured.

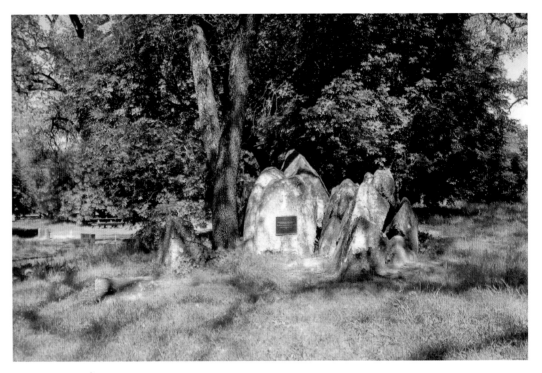

Pictured is a memorial for the Chinese who made their home in Loomis.

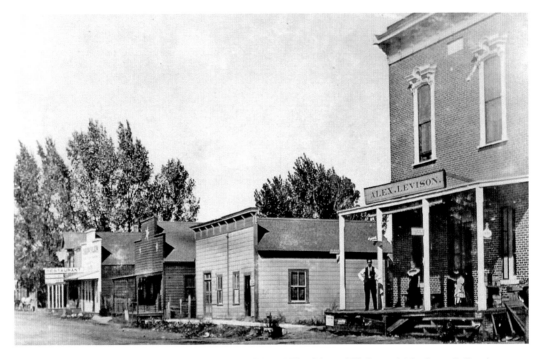

In 1877, three Chinese men were arrested for the murder of Mr. and Mrs. Oder and Mr. Sargent at the Sargent's Ranch outside of Rocklin. The citizens demanded that all Chinese leave town by 6 PM. By 4 PM, the last of the Chinese walked single file out of town. At 6 PM, the citizens demolished all twenty-five buildings in Rocklin's Chinatown.

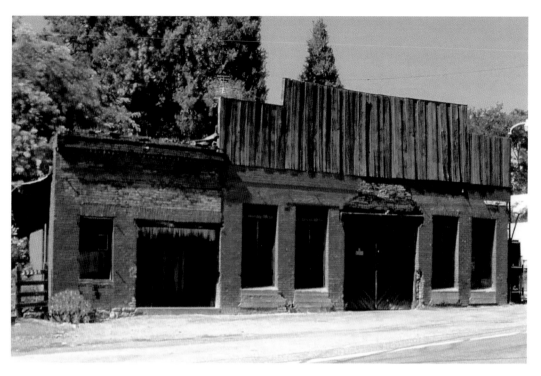

Gold was discovered in North San Juan in 1853. Many Chinese worked the gold mines in North San Juan. They are credited with starting the North San Juan Cherry Festival.

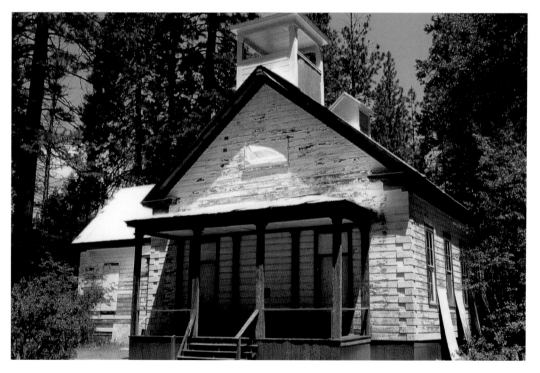

North Bloomfield in Nevada County got its start as a gold mining town in the mid-1850s. In 1857, when the post office was established, it had a population of 500 people.

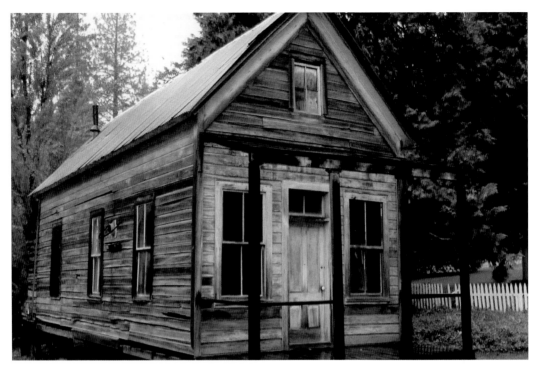

Once the North Bloomfield Mining and Gravel Company began doing hydraulic mining, miners came from near and far. The Chinese set up their own settlement on one end of town.

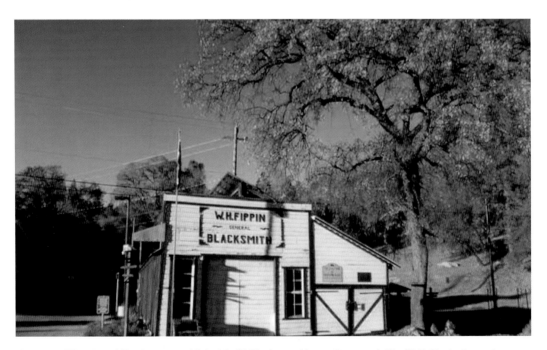

The town of Rough and Ready was established in 1849 when gold was discovered. The W. F. Fippin General Blacksmith shop is pictured after it was renovated. One pioneer thought he could steal gold from the Chinese in Rough and Ready. The Chinese quickly overpowered him, hog tied him, and slipped a bamboo pole through his bound hands and feet. They carried him to the local courthouse.

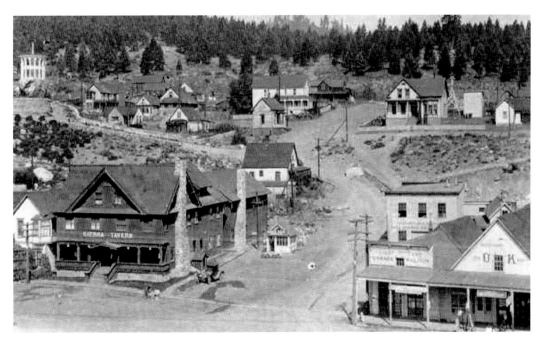

Truckee had a large population of Chinese who worked in the mines, the lumber industry, and on the railroad. The Truckee Chinatown burned in 1878 but was rebuilt on the outskirts of town. In 1886, during the anti-Chinese movement, Truckee's own "601 Vigilantes" and the "Caucasian League" ordered all Chinese residents to leave Truckee on their own or they would be shipped out in boxcars. The Chinese left on their own.

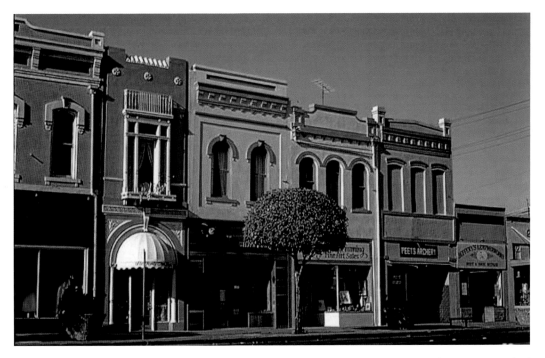

The Chinese who lived in Red Bluff built elaborate tunnels underneath the downtown. Most of the tunnels stretched out to the Sacramento River. As in most Chinatowns, there was a great deal of opium, gambling, and prostitution. By digging tunnels underground, the Chinese could unload cargo from the boats on the river without being noticed.

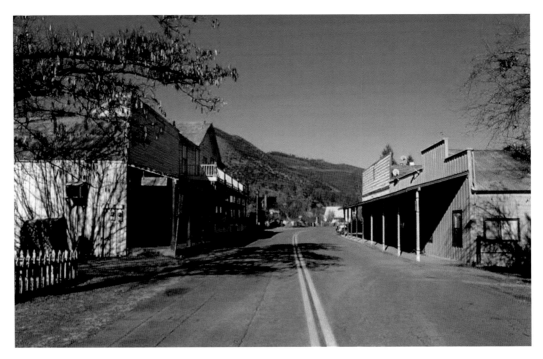

French Gulch was discovered by two French miners in 1849. The original name of the town was Morrowville. It quickly became a major gold mining hub.

The Chinese set up along the banks of Clear Creek outside of French Gulch. They grew vegetables to sell to the other settlers, they operated laundries, restaurants, and worked in the mines. French Gulch is credited with producing more than 20 million dollars in gold.

Shasta County was an important part of the Gold Rush. These ruins tell a story of the early day settlers who flocked to the town of Shasta. They set up towns and settled in but when the last of the gold was gone, they moved on.

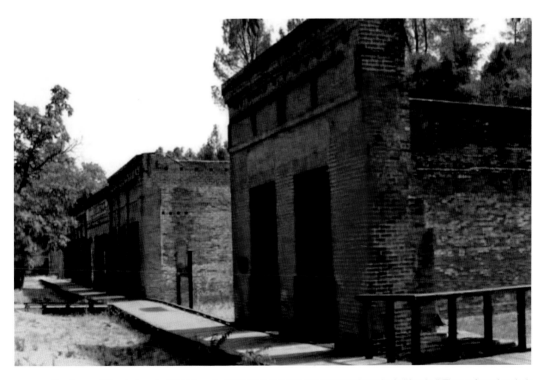

The town of Shasta boasted that they had the "longest row of brick buildings in California." They referred to their town as the "Queen City of the North."

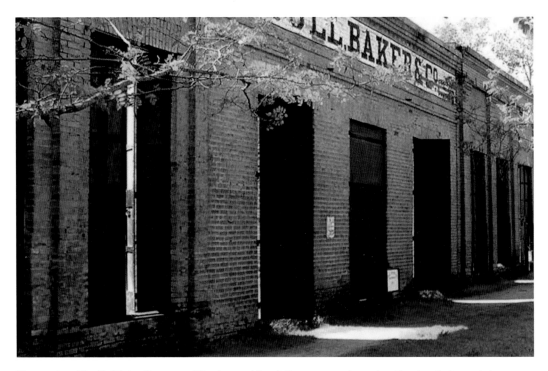

The remains of the Bull Baker Company of Shasta are pictured. It was a general merchandise store that ran ads in the newspaper stating: "Wanted - to exchange groceries of all kinds for cash." When the railroad bypassed the town of Shasta, the townsfolk moved away little by little until there was hardly anything remaining of the once bustling town.

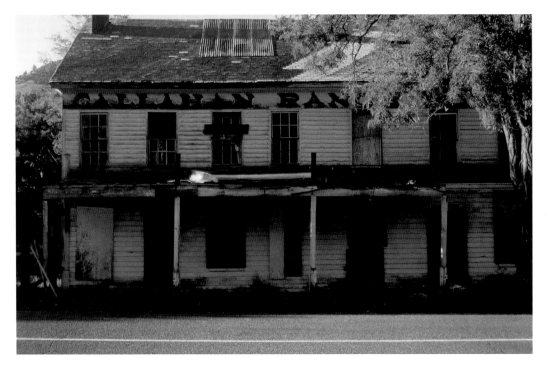

There was a time that Callahan's Ranch was teaming with miners during the Gold Rush. The first stage stop in Siskiyou County was at Callahan's Ranch.

Farrington's Store in the town of Callahan is pictured. When gold was discovered nearby, Chinese miners set up their own area.

An abandoned house in the town of Callahan is pictured. At one time this house was filled with laughter and stories but now it has been left to Mother Nature.

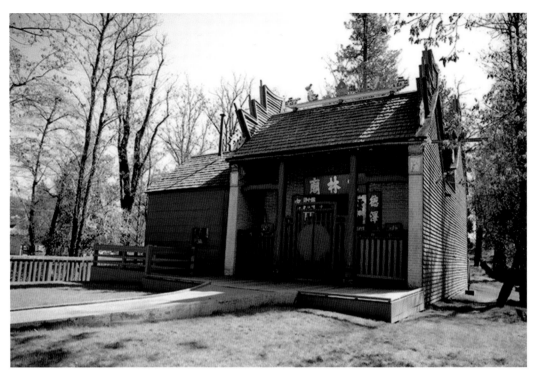

The Joss House in Weaverville is the oldest continuously used Joss House in California.

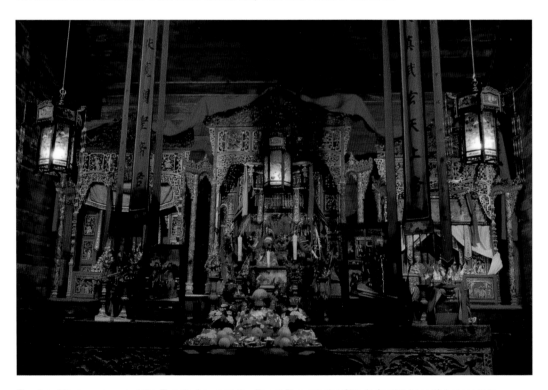

The Joss House was named the Temple Amongst the Forest Beneath the Clouds for the beautiful scenery in Weaverville.

Right: Pictured are Chinese men in Weaverville. The Chinese name for Weaverville was *Wee-bah Hong Yen Fow.* When gold was discovered in nearby Trinity River, thousands of Chinese arrived in the area. They settled in Weaverville and the surrounding areas of Junction City, Quinby, Douglas City, Lewiston, and Don Juan Bar.

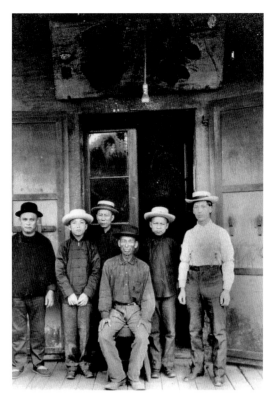

Below: The Chinatown in Yreka is pictured. There were a total of three Chinatowns in Yreka. The first was on West Miner Street. When they were pushed out of that location, they settled on Main Street. After two fires destroyed that Chinatown, they settled on Center Street. In 1969, when Interstate 5 was being built, the California State Parks performed a salvage dig. They located parts of ceramic bowls, opium tins, opium pipes, Chinese coins, and fragments of bottles.

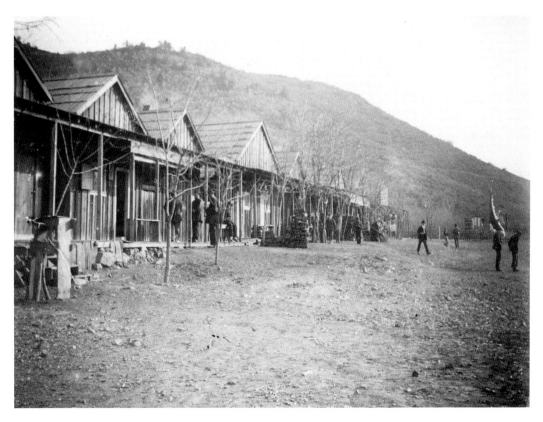

3

LOCKE

Walnut Grove had two separate Chinatowns. Many of the Chinese were employed building levees in the Delta. In 1915, both Chinatowns were devastated by a fire. Although work got underway to rebuild, many of the Chinese decided to move further up the delta. A committee was formed consisting of: Lee Bing, Chan Hing Sai, Tom Wai, Chan Dei Kee, Ng So Hat, Chan Wai Lum, Chow Hou Bun, and Suen Dat Suin. They contacted a nearby landowner by the name of George Locke. He agreed to lease part of his land. At the time the U.S. government prohibited the Chinese from owning land. It wasn't long before a Chinatown began to emerge. They named their new town Lockeport. In the 1920s, the name was shortened to Locke.

As the agriculture industry boomed in the Delta, the population of Locke increased. Soon they were known for gambling, prostitution, and opium dens. In 1919, the *Sacramento Bee* headlines screamed: *"Gambling Running Free at Towns in the Delta Region. Lockeport is the Monte Carlo of the State. Workingmen Daily Lose Their Savings to the Chinese."*

Locke is the only town in America built by the Chinese for the Chinese. In 1990, Locke was designated a National Historic Landmark.

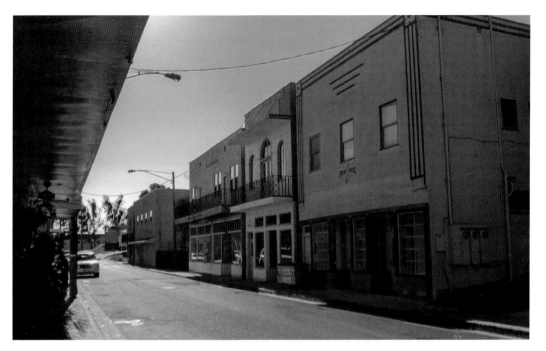

Walnut Grove was populated with many Chinese when a fire destroyed both of their Chinatowns in 1915. Some of the Chinese did stay and rebuild. They continued living and working in Walnut Grove until another fire swept through in 1937. Once again, they rebuilt, but this time, they used stucco instead of wood. The remaining buildings in Walnut Grove's Chinatown are pictured.

In 2000, at the age of eighty-two, Ping Lee told the *Californian* that he recalled chasing marbles down the wooden sidewalks and the smell of roast duck permeating the air when he was a child in Locke. He remembered a time that there were two water troughs on the wooden sidewalks for the horses who provided transportation in town.

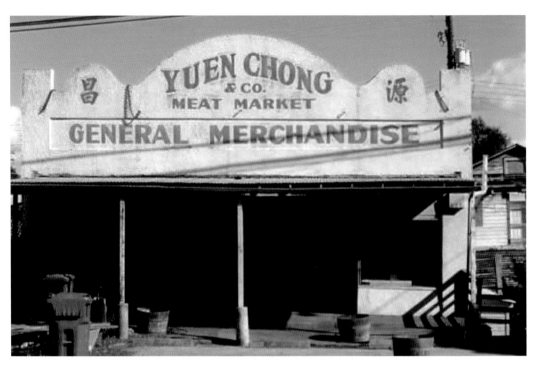

Ping's father, Lee Bing, was one of the founders of the town of Locke.

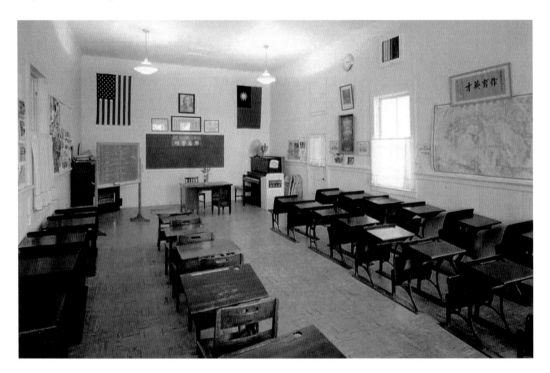

The school pictured was originally a town hall. The building was funded by the Kao Ming Tong (KMT), the Chinese Nationalist Party founded by Dr. Sun Yat Sen. In 1926, the building became the Kao Ming School. The school closed in the 1940s but the Joe Shoong Foundation provided funds to reopen the school in the 1950s. The school closed in the 1980s.

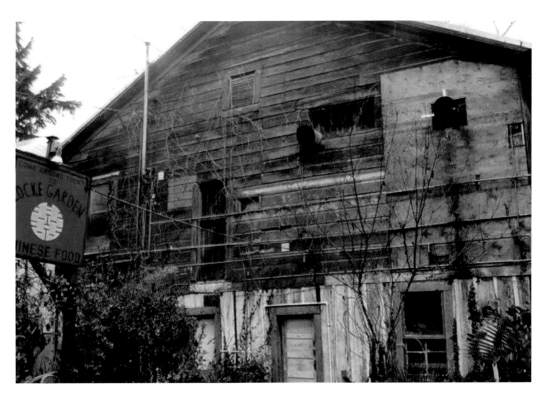

A lifelong resident of Locke, Yin Kwan Chan told the *Sacramento Bee* in 2015 about her father's journey to America. "He came by big ship, there were no planes then, to find the gold. When he realized there was no gold anymore, he went to work on a ranch in Courtland. He lived in a laborer's shack in the migrant camp, and sent money back on a regular basis to take care of the family."

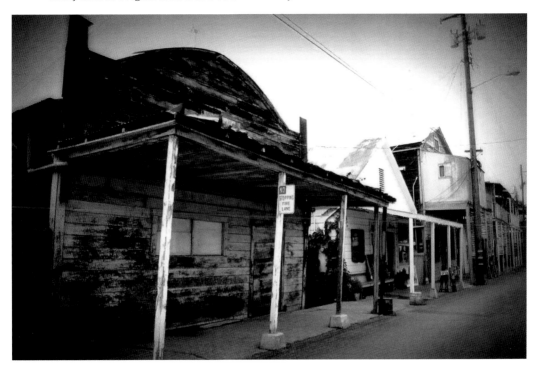

It did not take long to develop the reputation that anything goes in Locke. Gambling halls, opium dens, and brothels brought hundreds to town on the weekends. During Prohibition, liquor flowed freely. In the 1950s, all gambling halls were shut down in California and Locke became a sleepy little village.

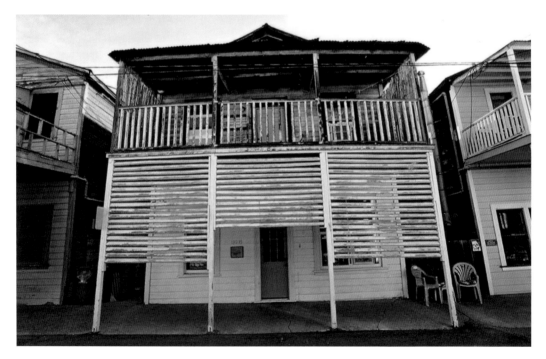

Locke resident Alex Eng told the *Sacramento Bee* that when he walks through the streets of Locke, "I feel the ghosts of the past. It's like walking through a piece of history. You can almost hear the people greeting each other, the kids playing in the streets."

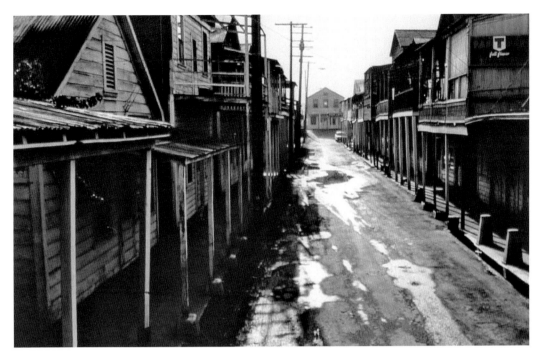

By the 1950s, Locke began to fall into disrepair. The buildings were staring to decay and the residents were leaving. Things only got worse over the next decades.

In the 1980s, things began to turn around when people saw the potential for preserving a part of California's history. Today the residents of Locke welcome tourists who want to take a step back in time.

4

WORKING ON THE RAILROAD

The earliest pioneers who came overland traveled by covered wagons. There were no railroads at the time. However, the 1860s saw a growing interest in connecting the newly populated West Coast with the East Coast, and railroads were the way to do that.

Numerous routes were studied as possibilities, but winter weather hampered each route under consideration. Theodore Judah was the chief engineer of the Sacramento Valley Railroad. He was convinced that a route through the Sierra Nevada could in fact be accomplished despite the winter weather. He submitted a proposal to Congress and became a lobbyist for the new railroad line. He met a miner by the name of Daniel Strong who had surveyed a toll road over the Sierra Nevada. They worked together and recruited a ten-man expedition team to survey the land in question. It was a four-month endeavor, but they concluded it was possible to run a train through the Sierra Nevada mountain range.

It took two tries, but they finally won approval by the House of Representatives and the Senate. President Lincoln signed the Pacific Railroad Act of 1862 into law on July 1, 1862.

Two companies were formed. The Union Pacific Railroad built from the east towards the west. The Central Pacific Railroad built in the opposite direction. Collis Huntington, Leland Stanford, Mark Hopkins, and Charles Crocker financed the costs of the Central Pacific Railroad that the government did not cover. They became known as "The Big Four" or "The Associates" as they preferred to be called.

Construction got underway on January 8, 1863. All the equipment had to be transported by ship around South America's Cape Horn or shipped to the Isthmus of Panama and then on to San Francisco or Sacramento. The wooden components were made using local timber.

There were numerous trials and tribulations attempting to build a railroad through the Sierra Nevada. For starters, they had to work in deep snow for more than half the year. The forest had to be cleared to make room for the railroad. Additionally, they had to blast away portions of mountains to create tunnels and snow sheds. They also had to create roadbeds for the tracks, build trestles, blast through or around hills, dig tunnels, lay the rails, drive the spikes, and bolt the fishplate bar to each rail. They were also building telegraph lines as they went using local timber for the poles.

Despite the odds, the Central Pacific Railroad met up with the Union Pacific Railroad in Promontory Summit, Utah, on May 10, 1869. The golden spike was laid, thereby creating the Transcontinental Railroad.

When the Transcontinental Railroad was completed, many of the Chinese worked on other railroad lines throughout the United States.

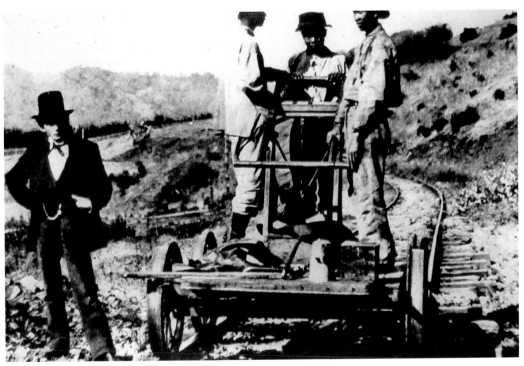

Charles Crocker suggested hiring Chinese workers to build the Central Pacific Railroad after he was unable to find enough pioneers willing to do the work. At the time there was a great deal of anti-Chinese sentiment. Nevertheless, he began with a small group of Chinese laborers in 1864. He recruited men living in China where work was scarce.

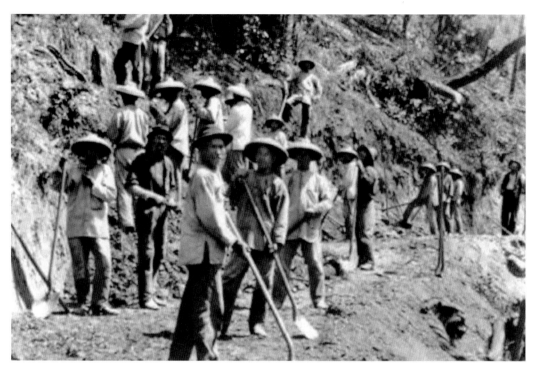

By the end of the project more than 20,000 Chinese men had worked on the Central Pacific Railroad.

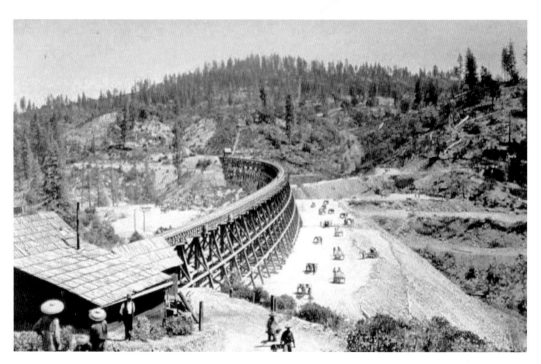

The Chinese pictured are working on the railroad trestle at Secret Town. Secret Town was a gold mining town that the miners tried to keep a secret. This trestle stretched 1,110 feet. After it was built it was determined that sparks from trains were causing fires on the wooden trestle. The Chinese were tasked with filling the trestle in with dirt to avoid fires from sparks when the trains went over the trestle. [*Photo courtesy of Placer County Museums*]

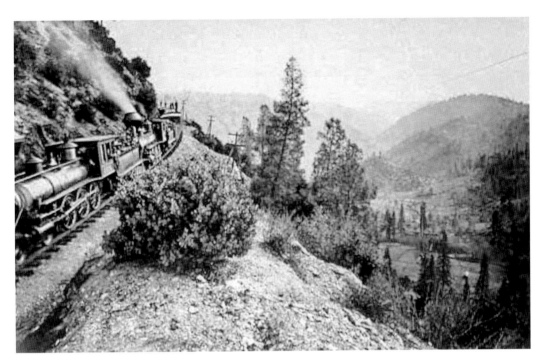

A train is making its way through the Cape Horn Promontory.

VIEW OF CAPE HORN PROMONTORY
NORTH FORK AMERICAN RIVER CANYON

DEDICATED TO THE MEMORY OF THOUSANDS OF CHINESE WHO WORKED FOR CHARLES CROCKER ON THE CENTRAL PACIFIC RAILROAD. THEY WERE LOWERED OVER THE FACE OF CAPE HORN PROMONTORY IN WICKER BOSUN'S CHAIRS TO A POINT 1332 FEET ABOVE THE CANYON FLOOR. THE LEDGE CREATED FOR THIS RAILBED WAS COMPLETED MAY 1866. THEY ARE HONORED FOR THEIR WORK ETHIC, AND TIMELY COMPLETION OF THE TRANSCONTINENTAL RAILS ENDING IN PROMOTORY, UTAH, MAY 1869.

DEDICATED MAY 8, 1999
COLFAX AREA HISTORICAL SOCIETY, INC.

This plaque is honoring the Chinese who worked on the Cape Horn Promontory. In order to lay the railroad track, they had to dynamite part of the mountain. They were lowered in wicker bosun chairs 1,332 feet above the floor of the North Fork American River Canyon. They would ignite the dynamite and then someone from above would quickly raise the chair out of harm's way.

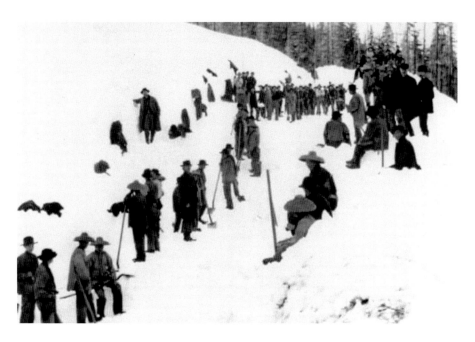

Above: Building a railroad in the Sierra Nevada proved difficult due to the fact that the ground is covered with snow more than half of the year. The Chinese workers pictured are working in the deep Sierra Nevada snow.

Left: Pictured is one page of Charles Crocker's payroll records from March 1865, listing the names of two dozen Chinese men. The Chinese men were paid 30-50 percent less than the pioneers. In 1867 the Chinese went on strike. The strike ended when the company cut off their food and supplies. Their pay and living conditions improved slightly after the strike.

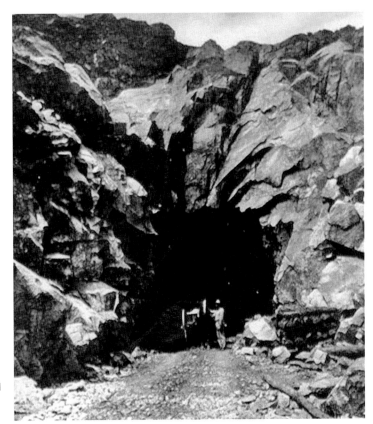

Building railroad tunnels required blasting dynamite into the mountains. Holes were pounded 3 to 5 feet into the rock face using a hammer and chisel. It could take two men an entire day to create one hole. The holes were filled with explosives that were lit on fire.

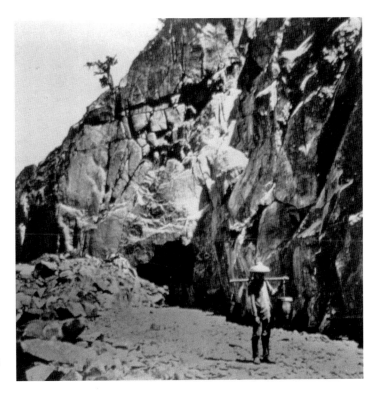

The Summit Tunnel at a length of more than 1,600 feet took two years to build.

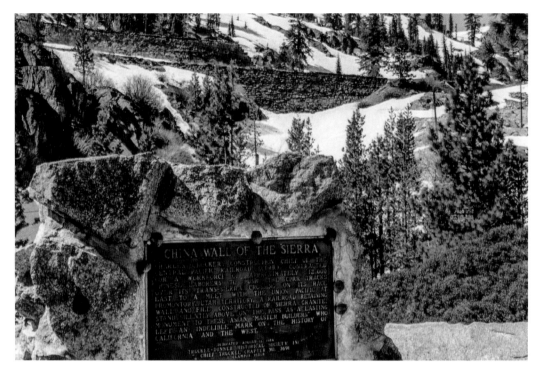

The Chinese are known for the Great Wall of China. The plaque pictured credits them for building the "Great Wall of the Sierra Nevada". Referring to the Chinese workers, the president of the Central Pacific Railroad, Leland Stanford told congress in 1865, "Without them it would be impossible to complete the western portion of this great national enterprise, within the time required by the Acts of Congress."

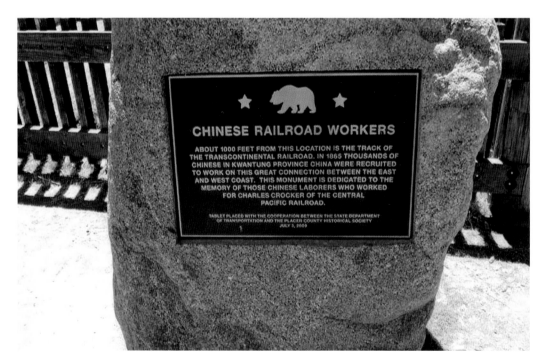

Pictured is another plaque honoring the Chinese workers.

5

ANTI-CHINESE SENTIMENT

The Six Associations secured contracts to place the Chinese workers at various jobs, be it mining, working on the railroad, building levees, working in factories and canneries, working in the agriculture industry, building tunnels, etc. The contracts paid the Chinese less than the non-Chinese. The pioneers felt that the Chinese were taking jobs away from them. They also resented the fact that the Chinese were sending their money back to their families in China, thereby not supporting the local economy. As more and more Chinese arrived on American soil, this resentment began to boil over. Fights broke out and many deaths occurred on both sides.

Meanwhile, the United States government was trying to keep peace with China in order to remain trade allies. In 1870, Congress passed the Naturalization Act which prevented the Chinese from becoming United States citizens. It also prevented Chinese women from immigrating to America if their husbands were living here. In 1880, the Angell Treaty limited the number of Chinese who could enter the United States. Even with the new treaty, tensions rang high. In 1882, Congress passed the Chinese Exclusion Act. This barred all Chinese, skilled and unskilled from entering the United States for ten years. In 1888, Congress added the Scott Act which prohibited the Chinese from returning to the United States if they went back to China for a visit. In 1892, when the Chinese Exclusion Act was due to expire, it was replaced by the Geary Act. The Geary Act extended the Chinese Exclusion Act for an additional ten years. It also required the Chinese to carry a Certificate of Residency with them at all times. The following year, the U.S. Supreme Court ruled that Congress had the power to expel the Chinese in Fong Yue Ting v. United States.

In 1904 Congress decided the Chinese Exclusion Act should remain in place

indefinitely. The Asian Exclusion Act of 1924 further cemented the exclusion of Chinese in America. It was 1943 before all the Chinese Exclusion Acts were repealed with the passing of the Magnuson Act. At the time, America needed China as an ally to fight the Japanese during World War II. Even with these changes, only 105 Chinese individuals could immigrate to America each year. That number was increased with the Immigration and Nationality Act of 1952 which also allowed citizenship. It wasn't until 1965 that the Chinese were free to enter the United States without restrictions and to seek citizenship.

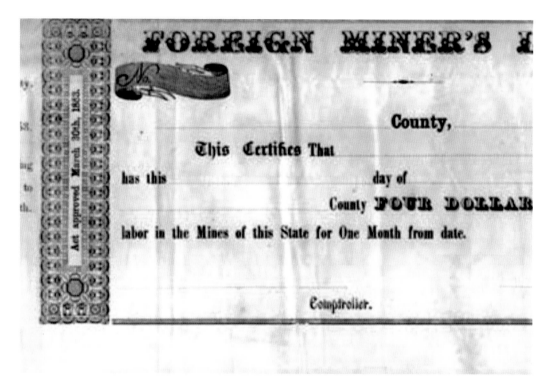

The Foreign Miner's Tax Act was passed in 1850. This meant that foreigners were required to pay $20 per month if they worked in the mining industry. The act was rescinded the following year but was quickly replaced by the Foreign Miners License Tax Act of 1852. This license fee began at $3 per month but was increased gradually over time.

Public No 71

Forty seventh

Congress of the United States, At the First Session,

Begun and held at the CITY OF WASHINGTON, in the DISTRICT OF COLUMBIA, on Monday, the _fifth_ day of December, eighteen hundred and eighty- _one_

An Act

To execute certain treaty stipulations relating to Chinese.

Whereas, In the opinion of the Government of the United States the coming of Chinese laborers to this country endangers the good order of certain localities within the territory thereof: Therefore, Be it enacted by the Senate and House of Representatives of the United States of America in Congress assembled, That from and after the expiration of ninety days next after the passage of this act, and until the expiration of ten years next after the passage of this act, the coming of Chinese laborers to the United States be, and the same is hereby, suspended; and during such suspension it shall not be lawful for any Chinese laborer to come, or, having so come after the expiration of said ninety days, to remain within the United States.

Sec. 2. That the master of any vessel who shall knowingly bring within the United States on such vessel, and land or permit to be landed, any Chinese laborer, from any foreign port or place, shall be deemed guilty of a misdemeanor, and on conviction thereof shall be punished by a fine of not more than five hundred dollars for each and every such Chinese laborer so brought, and may be also imprisoned for a term not exceeding one year.

Sec. 3. That the two foregoing sections shall not apply to Chinese laborers who were in the United States on the seventeenth day of November, eighteen hundred and eighty, or who shall have come into the same before the expiration of ninety days next after the passage of this act, and who shall produce

A copy of the Chinese Exclusion Act of 1882 is pictured. The act also prohibited the master of any vessel from knowingly bringing any Chinese laborer from any foreign port or place to the United States. To do so was a misdemeanor and conviction of such could result in a fine of not more than $500 for each Chinese laborer and imprisonment for a term of up to one year.

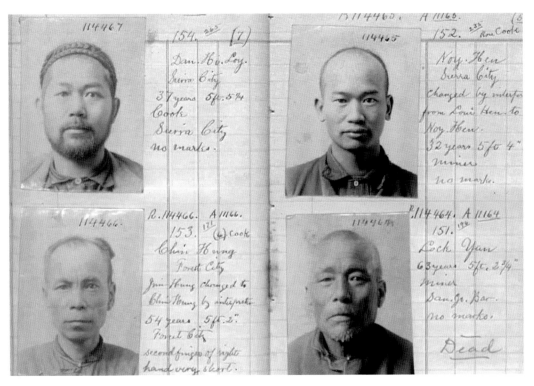

Pictured are documents relating to Chinese immigrants. Each photograph listed their name, age, physical description, and occupation.

Certificate of Residence.

Issued to Chinese _Labrer_ , under the Provisions of the Act of May 5, 1892.

This is to Certify THAT _Lung Saug Foon_ , a Chinese _Laborer_ , now residing at _San Jose Cal_ has made application No. _806_ to me for a Certificate of Residence, under the provisions of the Act of Congress approved May 5, 1892, and I certify that it appears from the affidavits of witnesses submitted with said application that said _Lung Saug Foon_ was within the limits of the United States at the time of the passage of said Act, and was then residing at _San Jose Cal_ and that he was at that time lawfully entitled to remain in the United States, and that the following is a descriptive list of said Chinese _Laborer_ viz:

NAME: _Lung Saug Foon_ AGE: _36 yrs_
LOCAL RESIDENCE: _San Jose Cal_
OCCUPATION: _Laundryman_ HEIGHT: _5 ft 5 in_ COLOR OF EYES: _Brown_
COMPLEXION: _Medium_ PHYSICAL MARKS OR PECULIARITIES FOR IDENTIFICATION: _Scar over rt eyebrow. Small tw mon on left eye_

And as a further means of identification, I have affixed hereto a photographic likeness of said _Lung Saug Foon_

GIVEN UNDER MY HAND AND SEAL THIS _27th_ day of _April 1894_ at _San Jose_
State of _California_

One part of the Geary Act required that every Chinese individual carry a certificate of residency at all times. Failure to do so could result in detention and deportation.

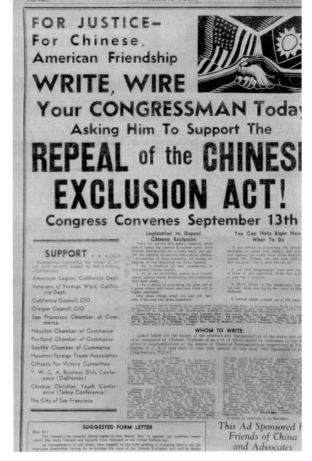

A poster asking people to support repealing the Chinese Exclusion Act is pictured. Although it was officially repealed in 1943, it would be decades before all restrictions were lifted.

Wong Kim Ark was born in San Francisco in 1873. Wong visited China in 1895. When he tried to return to the United States, he was denied entry despite showing the authorities paperwork proving he was born in America. In 1898, the U.S. Supreme Court ruled, "the American citizenship which Wong Kim Ark acquired by birth with the United States has not been lost or taken away by anything happening since his birth."

6

ANGEL ISLAND

Angel Island sits on 740 acres just north of San Francisco. During the Civil War, it served as a military post. After the Spanish-American War, the island was used for a discharge depot for returning troops. When fears of a bubonic plague swept through San Francisco, the island quarantined all persons arriving from China. During World War II, detainees from Japan and Germany were kept on Angel Island.

From 1910-1940, approximately 175,000 Chinese and 60,000 Japanese were detained at Angel Island. When they arrived by ship, they were taken to Angel Island to be questioned at length as to their nationality and their reasons for coming to the United States. Angel Island also served as a deportation center for the Chinese who were being sent home after it was shown that they were in the country illegally.

In 2000, Dale Ching told reporter Esther Wu that he came to America in 1937 when he was seventeen years old. The trip took twenty-two days by steamer. Dale had been told that his father would be waiting for him when his ship docked in San Francisco. Instead, he was met by armed guards who ordered all the Chinese into a boat. They were taken to Angel Island. Dale recalled, "When we landed at Angel Island, the guards took away our suitcases. We were allowed the clothes we had on and one change of underwear." Dale remembered the barbed wire on the roof and the guard stations on the property. Recalling his time spent in the barracks, he said, "The first time I came into this room, I wondered what I was doing here. I didn't do anything wrong. Everybody was assigned one bed and given one blanket. I thought this was a prison." He spoke of the communal shower and the fact that the barracks shared a wall with prisoners who were waiting to be transferred to Alcatraz Prison.

In 1922, some of the detainees organized the Angel Island Liberty Association. They organized games and classes for the detainees. Dale recalled, "We had an old

Victrola in here and a few opera recordings. Sometimes the men would organize classes or volleyball games." Mostly, the time was spent waiting in the barracks. The authorities told Dale he was being detained because his description of his house in China did not match what his uncle had told the authorities. Dale was detained for three months until his father was able to successfully petition for his release. Decades passed, but Dale never forget his first experience on American soil. One day he returned to Angel Island for the first time since being released. He recalled, "There were a lot of schoolchildren there on a field trip. I asked the teacher what she knew about Angel Island, and she said, 'nothing.' That made me feel bad. The way I look at it, history should not be forgotten. It needs to be told." It was for that reason Dale returned to Angel Island at the age of seventy-one, this time as a docent to lead tours and explain what life was like at Angel Island as a detainee.

Joy Dep Chin told reporter Esther Wu that she was detained on Angel Island for a month in 1926 when she was seventeen years old. She recalled, "There were a lot of beds. A lot of people were scared. They would cry all day and night. People were nervous. Many of them were paper sons or daughters. Everyone was afraid to talk to anyone. Anybody could be a spy, so nobody talked."

The San Francisco earthquake and fire destroyed all the immigration files. Many Chinese tried to enter America, claiming that they were American citizens. They became known as paper sons and daughters. Some successfully managed to enter the United States, but most were turned back.

Hugh Lem told the *San Francisco Examiner* that he arrived at Angel Island at the age of ten. He recalled, "You would look over from the island and see Coit Tower. 'Oh, that's the high building' you would say. That's San Francisco."

In 1976, Kew Yuen Ja told the *Napa Valley Register* that he left his home in Canton, China, when he was twenty-seven years old. He explained his reason for doing so: "The people had a hard time to find jobs in China then. They had to go outside to make a living." When Kew arrived at Angel Island in 1939, he was detained for one month. He said they were only allowed to leave the barracks for meals and for one hour a day for exercise. Kew said they passed the time playing mahjong, singing, and reading books. He said the meals were usually rice and beans, adding, "It was not too good, but anyway you just want to fill up your stomach, that's all." Thirty-six years after he was allowed to leave Angel Island, he returned to visit. The memories came flooding back and he said, "The immigration laws were not too fair, I think. It was frustrating. This place left a very deep impression on me."

In 1926, at the age of fourteen, James Som arrived at Angel Island with his mother. Sixty years later he spoke to the *San Francisco Examiner* about his fond memories of San Francisco in the 1930s. He remembered the "cobblestone streets, the early

morning smells of the markets and the talk in the evening among neighbors." He returned to China in 1978 and again in 1982. James spoke of the poverty that plagued his homeland and said, "That's why people come to the United States, because you suffer over there. Things are much better, improving. But you cannot compare the United States. Best in the world, right? You cannot compare."

Although Angel Island was called the Ellis Island of the West, it served a different purpose. It was geared towards preventing the Chinese from entering the United States. The Chinese were kept on the island for weeks, months, and in some instances up to two years.

Above: Prior to using Angel Island for an immigration and deportation center, officials used a two-story shed at the Pacific Mail Steamship Company. In 1955, the California State Park Commission purchased part of Angel Island. As the years went by, they made additional purchases of land. In 1963, Angel Island became a state park.

Left: The interior of Angel Island is pictured prior to renovations.

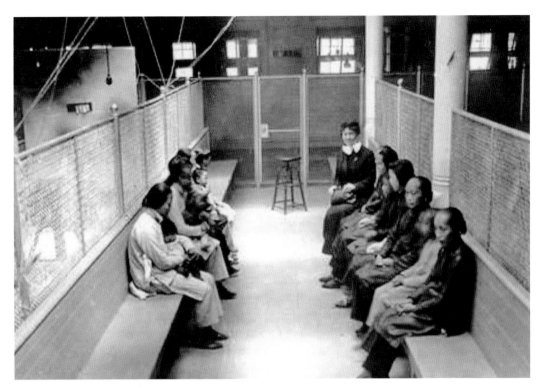

Women and children arriving at Angel Island were kept separate from the men. They walked from the barracks to the dining room in separate shifts.

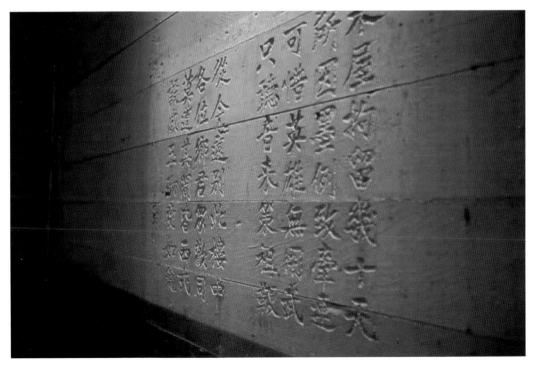

The Chinese had many hours to wile away while staying at Angel Island.

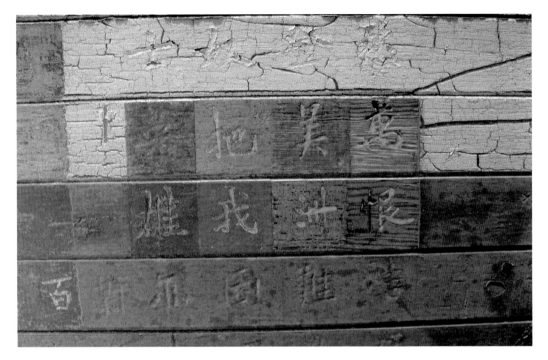

Some of the Chinese wrote poetry on the walls in their native Chinese writing. The translation of what Ngoot P. Chin wrote in Chinese characters about the experience: "Leaving their homes and villages, they crossed the ocean. Only to endure confinement in these barracks. Conquering frontiers and barriers, they pioneered a new life by the Golden Gate."

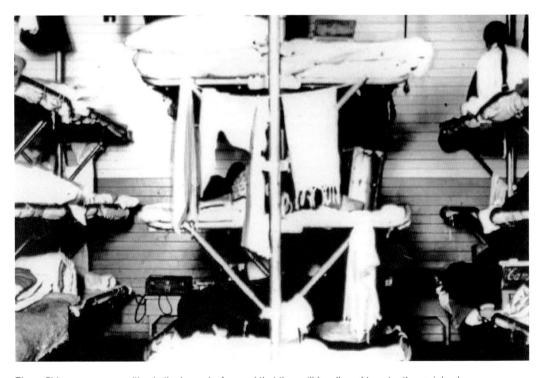

These Chinese men are waiting in the barracks for word that they will be allowed to enter the mainland.

7

THE LONG WAY HOME

For the Chinese who came to America, it was very important that their bones be returned to China upon their death. They would go without food in order to save money for their burial and return to their homeland. The Chinese had an idiom, *luo ye gui gen*, or falling leaves return to root. Their belief was that immigrants belonged with their ancestors at home. Another saying, *luo ye sheng gen*, meant falling to the ground, growing roots. This meant if the immigrant did not return home, the new country would become his homeland, thus destroying the continuity of his family.

The Chinese held elaborate funeral processions. If possible, white would be worn by those in the funeral procession. They would walk to the cemetery tossing small pieces of paper as they went. Each piece of paper was perforated with holes in it. It was believed that if there were holes in the paper that evil spirits could not pass through it, and they could bury the deceased before the evil spirits could get to the body. Musical instruments were played as they walked to the cemetery. Hired mourners would wail and act despondent. Once at the gravesite, a huge feast would be laid out. The Chinese did not want the deceased to go to their next life without food. They would toss fake money and clothes on the gravesite so that the deceased would have money and clothing in their next life. Some Chinese cemeteries had a funerary burner. The funerary burner was used to burn the clothing and the fake money so that the deceased would have those items in their next life. If there was no funerary burner, sometimes they lit the items on fire, and other times they simply left them on the gravesite.

In Yreka, there was an older Chinese man who went by the name of Old Sacramento. He was asked why the Chinese left such elaborate feasts on the grave

of the deceased. He replied, "Alle same white man, he put them beautiful flowers on grave dead white man, he no come up to smell them."

Repatriation of bones meant that someone would come from China to collect the bones. The bones would be cleansed, bundled together, and placed in a zinc box or urn. That vessel would then be placed in a wooden bone box and returned to China. The remains of 100,000 Chinese came through the Tung Wah Coffin House between 1875-1949. The remains were from the United States, Canada, Australia, and other countries where the Chinese had gone in search of a better life. The Tung Wah Coffin House ran advertisements in local newspapers alerting families to the return of the deceased. If no one claimed the box, the caretakers at the Tung Wah Coffin House would assume responsibility. They would honor the deceased with daily rituals and lighting of incense.

This postcard shows preparations for a Chinese burial in San Francisco's Chinatown. If the deceased had been a prominent citizen, such as a merchant, the coffin would be placed on the street the day of the funeral as seen in this postcard.

Bricks were sometimes left with the deceased with their name inscribed. This helped with the repatriation process. *Qing Ming* (Pure Brightness) is a Chinese ceremony that is held during the spring. During the ceremony the graves are swept and cleaned to show respect for the deceased. Another festival is *Yulanpen* (Hungry Ghosts). This ceremony is held to pacify the spirits who are restless, because they did not have a proper burial.

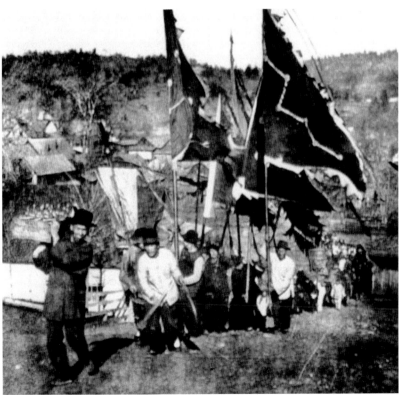

Pictured is a funeral procession in Weaverville. The Chinese would go without food if necessary in order to save money for their funeral. After Wo Yuen Hoo died at age seventy, his wife, Ong Shee Hoo, had to raise their nine children. It took her a year to pay for the funeral, which cost $70.

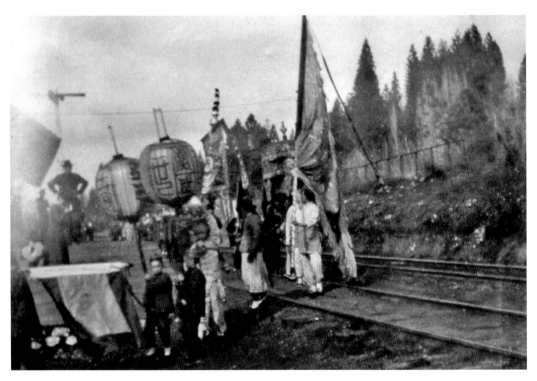

Pictured are funeral processions in Dutch Flat. The funeral processions were viewed with curiosity by the pioneers who would line up on the sidewalks to watch the processions. [*Photos courtesy of Placer County Museums*]

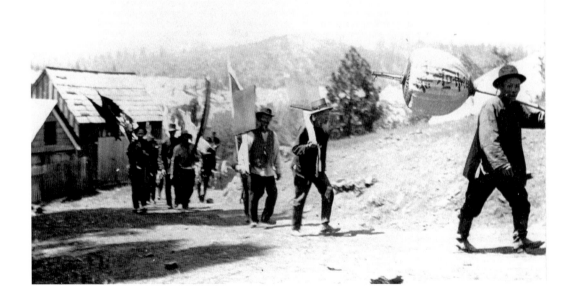